PHOTOGRAPHY AT THE MUSÉE D'ORSAY

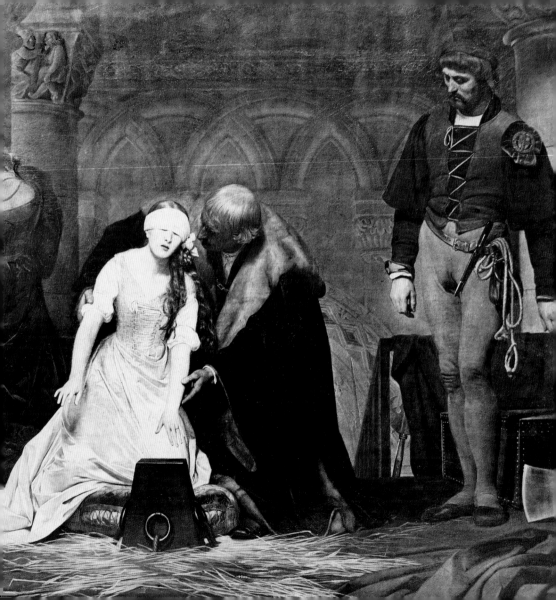

Dominique de Font-Réaulx, Joëlle Bolloch

The Work of Art and Its Reproduction

Musée d'Orsay

5 CONTINENTS

This collection is directed by Serge Lemoine, Chairman of the Musée d'Orsay. All works reproduced in this volume belong to the Musée d'Orsay's collection and are kept in the museum.

This book has been conceived for the exhibition *L'œuvre d'art et sa reproduction photographique* at Musée d'Orsay, 27th June – 24th September 2006.

The authors would especially like to thank Marc Boulay, Laure Boyer, Catherine Bridonneau, Marianne Castan, Clarisse Duclos, Isabelle Gaétan, Christian Garoscio, Nadine Gastaldi, Fabrice Golec, Pierre-Yves Laborde, Geneviève Lacambre, Dominique Lobstein, Laure de Margerie, Marie-Madeleine Massé, Anne Pingeot, Pierre-Lin Renié.

www.musee-orsay.fr
info@5continentseditions.com

ISBN Musée d'Orsay : 2-905724-45-5
ISBN 5 Continents Éditions : 88-7439-326-1

Cover
Ad. Braun & Cie (1876-1889), or Maison Ad. Braun & Cie. Braun Clément & Cie Successeurs *Musée du Louvre, la salle de Michel-Ange* 1883-1896

For the Musée d'Orsay

Publication manager
Annie Dufour

Assisted by
Anne-Claire Juramie

Iconography and digitalization
Patrice Schmidt et Alexis Brandt

For 5 Continents Editions

Translation
Isabel Ollivier

Editorial Coordinator
Laura Maggioni

Design
Lara Gariboldi

Layout
Virginia Maccagno

Editing
Timothy Stroud

Colour Separation
Eurofotolit, Cernusco sul Naviglio (Milan)

Printed in May 2006
by Grafiche Milani, Segrate (Milan), Italy

Printed in Italy

Table of Contents

Dominique de Font-Réaulx

The Work of Art and Its Reproduction

"The *daguerotype* [sic] is destined to reproduce the beauty of nature and art [...]; it is the ceaseless, spontaneous, tireless representation of 100,000 masterpieces that time has cast or constructed on the surface of the globe. [...] It is destined to popularise among us, at little expense, the finest works of art of which we have only costly and unfaithful copies; before long, if we do not wish to become our own engravers, we shall send our children to the museum saying: 'In three hours you must bring me back a painting by Murillo or Raphael.'" Jules Janin's rather naive enthusiasm in *L'Artiste* in 1839 echoes that of Arago speaking to the Academy of Science and then to the House of Representatives: "The drawings [of the daguerreotype] will be more faithful in every respect than the works of the most skilful painters". The fledgling technique of photography emerged from their writing as the perfect solution for artists seeking to have their work copied. Eager to promote the new invention, they glossed over the—crucial—technical and artistic stakes involved in photographic reproduction.

Historians of photography have long ignored art reproductions. This deliberate omission is understandable; struggling to give photography legitimate status as an art form, they have preferred to avoid an aspect which reduced the object of their study to the ancillary role of "humble servant", which was pinpointed by Charles Baudelaire in his report on the Salon of 1859 and locked photography into a purely documentary role in relation to painting and sculpture. In so doing, they overlooked the technical brilliance and aesthetic inventiveness achieved by the early photographers in their attempts to reproduce art. Until recent research by Stephen Bann and Anthony Hamber in Great Britain and Ann McCauley in the United States, and Pierre-Lin Renié's remarkable study of the collection in the Musée Goupil in France, histories of photography only mentioned briefly of the attempts made by the pioneers of photography to reproduce engravings,

paintings and sculptures on paper: Nicéphore Niépce's first heliographs (cat. 2), Hippolyte Bayard's direct positives (cat. 1) or the calotypes produced by William Fox Talbot (cat. 15), who included twenty four reproductions of works of art in his *Pencil of Nature* and, as early as 1839, tried to use photography to copy one of the paintings in his family home. Such summary treatment gives the impression that after these remarkable early attempts, photographic reproduction was of no interest and fell outside the sphere of creativity.

That would be to ignore the fact that, for the first great photographers, there was a major artistic stake involved in copying art works, especially in relation to engraving. As Henri Zerner recently recalled, it was in this field that the future of art photography was largely played out. Faithfully serving painting and drawing, in particular, was an opportunity to prove the photographer's ability to understand the artist's spirit, to grasp his manner and to transcribe it accurately. Francis Wey thus praised photography on paper in 1851: "If the artist-copyist and the engraver are knowledgeable and skilful, they will change the character of the model, and if they are not, they will fail to copy it. The only remedy for these difficulties is heliography and it is in this field that it will do wonders" (*La Lumière*, 23rd March 1851). The technical constraints of lighting, the difficulty of rendering the values of the painting, and the impossibility of moving the work to be photographed further exalted their talent. In 1845, Pierre-Ambroise Richebourg made two daguerreotypes of architectural drawings presented at the Salon by Hippolyte Durand (cat. 4, 5); the architect's rigorous manner is heightened by the precision and clarity of the daguerreotype plates and their total lack of distortion. In 1846, Humbert de Molard turned his hand to daguerreotypes and copied works of art; one of them reproduced Henriquel-Dupont's engraving of *Lord Strafford* (Musée Gatien-Bonnet,

Lagny-sur-Marne) by Paul Delaroche; the plate is a faithful copy of the print, enhancing the precise line and the beautiful quality of the blacks. The photographer's dexterity has captured the sensitivity of the picture. Humbert de Molard was attached to these works and decided to show the daguerreotypes at the first exhibition of the Société Française de Photographie, on the fringe of the Universal Exhibition of 1855.

In 1849, Gustave Le Gray exhibited several photographs on paper of art works at the Products of Industry Fair in 1849 – probably including prints of paintings by his friend Jean-Léon Gérôme. In his report on the exhibition published in *La Lumière* in March 1851, Léon de Laborde, a curator at the Louvre and an eminent archaeologist, was lavish in his praise for the man who in the meantime had become his photography tutor: "This young painter has applied himself to subjects which were part of his early training, to portraiture and the reproduction of paintings and objets d'art. […] The paintings that he has copied, the objets d'art that he has reproduced are master-pieces, delicately finished and pleasingly faithful." The very fine daguerreotype exe-cuted by Le Gray in 1848 after *Anacreon, Bacchus and Cupid* by Jean-Léon Gérôme (private collection) and his 1854 photographs on paper of the *Mona Lisa* (1854), after a drawing by Aimé Millet, in which he varied the colours of the prints, emphasise the photographer's extraordinary dexterity in reproducing great works of art. The photo-graphs of the rooms of the Salon in 1852, along with a remarkable print of the Salon of 1850–51, commissioned from Le Gray by Philippe de Chennevières, give proof of his ability to overcome dim interior lighting and to choose the right distance and cam-era angle (cat. 13, 14).

Impressed by Le Gray's accomplished work, in 1850 Laborde put before the Ministry of Education a far-sighted project for a comprehensive photographic inventory of all the

public collections, starting with the 10,000 objects then in the Louvre. In March 1851, in the feature article in *La Lumière*, the magazine founded by the members of the Société héliographique, Francis Wey, admiring Fortier's photograph of Leonardo da Vinci's *Last Supper*, suggested devoting a room in the Louvre to photographic prints of paintings missing from the national collections: "Photography provides us with a cheap, sure and mathematical means of acquiring, in the interests of study and art history, valuable notions about the Old Masters of whom France does not own a single painting." In 1854, the Mayer brothers launched the idea of a national subscription to set up a state-owned historical photography museum: "The third part [of this museum] will be devoted to the photographic reproduction of objets d'art sold, often abroad, by the artists themselves, works that the genius of the craftsman or the artist often cannot recreate and of which the museum would then own a true copy, such as paintings, statues, large marbles, bronzes, gold work..." (Archives centrales des musées nationaux, AMN, series Z18).

So, from the early 1850s, art reproduction by photography raised the hopes of art historians, who admired the degree of excellence achieved by the early photographers. The prizes awarded at the Universal Exhibition in Paris in 1855, on the fringe of which the Société française de photographie held its first exhibition, reflected this praise: more than ten first-class medals were awarded to photographers who had presented reproductions of art works, either individually—Baldus, Bisson, Bingham, Blanquart-Évrard, Braun, Thurston Thompson—or with other works—Nègre, Le Secq. In his review of the exhibition, Ernest Lacan marvelled over Henri Le Secq's reproductions: "As for his copies of paintings, they may be cited among the most remarkable prints in this genre. The difficulties inherent in this work are well known. M. le Secq has over-

come them with praiseworthy success […]" (*La Lumière*, 27th October 1855). At the same exhibition, Benjamin Delessert showed photographs of the engravings by Marc-Antoine Raimondi published by Goupil in 1853 (cat. 12). To emphasise the quality of his prints, he presented the original engraving and the reproduction side by side in the same frame, each with its price tag. "That gives irrefutable proof", wrote Lacan, "of the importance of photography from the double viewpoint of art and industry. What the photographer seeks in the master's engraving is the beauty of the forms, the skill of the composition, the simplicity of the technique, in short, everything which reveals the artist's genius" *(La Lumière*, 30th October 1855). So Delessert managed to establish photography's ability to provide reproductions of old masters as artists' models. Henry Delaborde, the curator of the Prints Department of the Imperial Library, leapt to the defence of the engravers whose work seemed to be threatened by the new invention: "Engraving therefore has a twofold task to fill. It must both copy and comment on the painting […]. Photography, on the contrary, proceeding only from fact, starts and finishes with fact. [...]. Beyond this all-out assimilation, it does not exist" (*Revue des deux mondes*, 1st April 1856).

Although engravings or drawings could be reproduced by photography relatively simply —because they were usually small, monochrome and used line rather than colour— paintings were a real challenge. For many decades, photographers stumbled on the impossibility of reproducing the colours of the canvas. Translating the values of the paint was already an exploit considering the sensitivity of the collodion which failed to transcribe some colours of the spectrum correctly: although the blues were well reproduced, fixing the reds and yellows was much more complicated. Robert Jefferson Bingham, a photographer at the Great Exhibition in London in 1851, moved to France in 1855; he

excelled in reproducing the coloured values of paintings. In 1858, Goupil published *L'Œuvre de Paul Delaroche*, illustrated by Bingham's photographs (cat. 22, 23, 24, 25); this set was the first catalogue raisonné of a painter's work accompanied by photographs. Théophile Gautier paid homage to this publication in a long article in *L'Artiste* (7th March 1858). He praised the photographer's skill in interpreting and enhancing the paintings: "When it comes to painting, photography, despite the bourgeois sentiments it is imputed with, becomes an artist and interprets the canvas in front of its lens in its own manner. It can judiciously hide superfluous or obtrusive details under a dark tone and reserves its best light for the figure that interests it." Gautier astutely perceived that Bingham served Delaroche's dramatic style, and amplified the narrative aspect of his painting. He concluded by refuting the servile nature of photography: "So exact before nature, it becomes fanciful when faced with paintings; it extinguishes or illuminates them at will […]."

The history of the introduction of photography in French institutions has yet to be written. The records of the National Museums from the early 1850s to the end of the nineteenth century reveal a complex situation in which enthusiasm is tinged with suspicion. Laborde's 1850 project remained a dead letter; although photographers seemed to have been admitted to the museum until the early 1860s, there was no concerted project to photograph the collections, as there was at the British Museum in the 1850s with Roger Fenton. Some curators were wary of photography of art works, and of paintings in particular. Frédéric Villot thus wrote in reply to a request from Braun: "I do not know if M. Braun has improved the science of photography so as to be able to avoid the pitfalls into which everybody who has tried to reproduced paintings *directly* has so far fallen" (AMN, series C19, 25th January 1865). Some time later, Adolphe Braun was photo-

graphing masterpieces by Michelangelo in Rome, showing that he had managed to overcome the difficulties of rendering the exact values of the paint (cat. 38, 39, 40, 41). On 27th July 1866, the Director of Fine Arts, Nieuwerkerke, issued a decree suspending all photographic permits: "Permits to take photographs in the galleries of the Louvre are recognised as detrimental to the preservation of the monuments; the photographers are very careless in their work, treating the galleries like studios and spilling corrosive substances that damage the flooring and stairs; as from 1st August, all permits to take photographs are cancelled without exception until further notice" (AMN, series T18). However, an exception was made for Charles Marville, who had been working at the museum as a photographer from the early 1850s, styling himself, with the tacit consent of Nieuwerkerke, "Photographer of the Imperial Museums". Indeed, he was once more admitted to the Louvre in 1867.

On 21st November 1872, the Conservatory of National Museums once again authorised photography in the museum, but laid down strict conditions: the paintings could not be moved, only two photographers would be admitted per department, the photographers could use dry collodion only (wet collodion required more handling on the spot); and specified that, in return, "the photographers must file with the archives of the Louvre two prints of each photograph made from works of art exhibited in the galleries" (AMN, series T18). It was not until 3rd December 1883 that a contract was signed by which the administration of the National Museums entrusted the firm of Adolphe Braun with the photography of the collections in the Louvre for a term of thirty years (AMN, series Z34).

At the same time, from the late 1850s, the Department of Fine Arts purchased various art books illustrated by photography, intended for provincial art schools or museums.

In 1853, Félix Ravaisson, then Inspector of Fine Arts, set up a committee to investigate the introduction of photography in the teaching of drawing in high schools and the use of photographs instead of engravings of drawings by Old Masters: "Photography can also assist the pencil and the burin, whether by multiplying the drawings of good artists or by providing immediate reproductions of great paintings." The committee brought together several artists—the sculptor Simart, the painters Picot, Hippolyte Flandrin, and Eugène Delacroix—as well as Alexandre Brongniart, the director of the Sèvres porcelain factory; Ingres was approached but did not take part. Although the committee does not seem to have had an immediate impact, the National Archives have records of several orders some years later: eight copies of *Les Œuvres de Paul Delaroche*, photographed by Bingham, were bought in 1859; ten copies of the *Dessins des grands maîtres des galeries de Vienne, Florence, Venise* by Luigi Bardi, each containing 200 photographs, were bought in 1861, one of them for the Dijon École des Beaux-Arts; ten copies of Richebourg's *Les Principaux Tableaux de l'exposition de 1861* were ordered from the artist in 1862; and several copies of the album of *Bas-reliefs antiques du musée Napoléon*, illustrated by photographs by Charles Marville, were attributed to various art schools in 1864—Limoges, Roubaix, Nancy, Tourcoing, Strasbourg, Lunéville, Bordeaux and Caen. In 1873, the state purchased Marville's photographs of 120 drawings by Ingres, for the Ingres museum in Montauban. Photography was already playing an essential role in the distribution of art works, although it was still hampered by the high cost of these various publications—thus, Bardi received 10,560 francs for his album of Italian masterpieces, and each copy of the Delaroche album went for 550 francs, a price justified by the original prints.

The collection of photographic reproductions at the Musee d'Orsay was built up on the fringe of major acquisitions, through transfers from the library of the Louvre, donations,

and artists' papers; it includes several fine sets, albums or portfolios, as well as a number of excellent single prints. It needs to be studied in liaison with the other major national collections, in the Bibliothèque nationale de France, the École nationale supérieure des beaux-arts, and the Musée Goupil, in particular. We trust that this book will set the ball rolling.

Joëlle Bolloch

Entries

1. Hippolyte Bayard (Breteuil, France, 1801 – Nemours, France, 1887), *Nature morte avec moulages*, 1839–40 [Still Life with Plaster Casts]. Salted paper print from the original direct positive, 12.2 x 12.5 cm. Plate from Blanquart-Évrard *La Photographie, ses origines, ses progrès, ses transformations*, 1869. Gift of the Kodak-Pathé Foundation. PHO 1983 165 158 4

Bayard used plaster moulds from his collection, arranging them in various combinations and sometimes posing among them himself. These objects had the twofold advantage of reflecting light well because of their whiteness and leaving the photographer free to arrange them as he pleased. The publisher Louis-Désiré Blanquart-Évrard (Lille, France, 1802–72) used this print as the first illustration in his book on the history of photographic processes, with a tribute to the author whom he considered "our most ingenious and skilled operator".

2. After **Joseph Nicéphore Niépce** (Chalon-sur-Saône, France, 1765 – Saint-Loup-de-Varennes, France, 1833), *Le Cardinal d'Amboise* [The Cardinal d'Amboise], photogravure by Messrs Cadart & Luce, from a heliograph by Niépce made in 1826, 22.8 x 13 cm. Plate from Blanquart-Évrard *La Photographie, ses origines, ses progrès, ses transformations*, 1869. Gift of the Kodak-Pathé Foundation. PHO 1983 165 158 11

In 1826, Niépce achieved satisfactory results with reproductions of engravings on a tin plate, including a copy of *The Cardinal d'Amboise* after Isaac Briot (1585–1670). This historic print was also chosen by Blanquart-Évrard, who gave credit to its inventor; Niépce had remained obscure "until the day when, after experiments with the strengths and weaknesses of photogenic printing, it was recognised that photography's true field is right where Nicéphore Niépce had put it".

3. Anonymous, *"Sainte Barbe", dessin sur panneau par Jean Van Eyck, musée d'Anvers*, ca 1850 [Sainte Barbe, drawing on panel by Jean Van Eyck, Antwerp Museum]. Gelatin print on paper sensitised with potassium iodide, 15 x 9 cm. Plate from Blanquart-Évrard *Album photographique de l'artiste et de l'amateur*, 1851.
PHO 1985 238

In 1851, Blanquart-Évrard opened a photographic press at Loos-lès-Lille and began work on his first album. The relatively moderately priced *Album photographique de l'artiste et de l'amateur* provided photographs of masterpieces of painting and sculpture, various monuments and sites, and archaeological curiosities, taken in France, Italy, Belgium, Greece and the Far East.

4–5. Pierre-Ambroise Richebourg (Paris, France, 1810 – ca 1875), *Élévations latérale et de la façade d'une église néo-gothique* and *Deux coupes du projet d'un même édifice, dessins de l'architecte Hippolyte Durand*, ca 1845 [Side and front elevations of a Neo-Gothic church, *and* Two cross-sections of the plans of a same building, drawings by the architect Hippolyte Durand]. Half-plate daguerreotypes, each 11.5 x 15.5 cm.
PHO 2005 1 1 and 2

These plates were probably made when Hippolyte Durand (1801–82) presented his drawings at the Salon of 1845, at the request of the architect himself or of

his publisher, Didron, with a view to airing the architect's ideas and achievements. They show Richebourg's early interest in the reproduction of art, an interest confirmed throughout the photographer's career.

6. P. Allain (active in Paris in the 1870s), *Ostensoir et son exposition pour l'église de La Madeleine*, after 1876 [Monstrance and its Stand for the Church of La Madeleine]. Albumen print from a collodion glass negative, 42 x 27.2 cm.
PHO 1984 64 7
Hoping to secure the church's custom, Émile Froment-Meurice (1837–1913) sent a letter to the parish priest of Saint-Augustin, enclosing photographs of the main items of religious gold work made by the Froment-Meurice firm. This monstrance with its imposing stand, two metres tall, had been commissioned by the abbot Deguerry for the Church of La Madeleine.

7–8. Pierre-Ambroise Richebourg, *Présenta-tion des œuvres de Froment-Meurice à l'exposition de 1849*, 1849 and *Coupe offerte par son Altesse Impériale le Prince Jérôme à son Altesse Impériale la Princesse Mathilde*, ca 1858 [Presentation of the Works of Froment-Meurice at the 1849 Exhibition *and* Cup Given by his Imperial Highness Prince Jerome to her Imperial Highness Princess Mathilde]. Salted paper prints, 14 x 20 and 17.2 x 12.7 cm.
PHO 1981 38 9 and 12
In 1858, in memory of François-Désiré Froment-Meurice (1801–55), his son Émile commissioned an album of photographs and engravings of works by the famous goldsmith. Pierre-Ambroise Richebourg, and the Bisson brothers, Auguste (1826–1900) and

Louis (1814–76) took the photographs, in which each object is centred against a neutral background. The album also includes a photograph of the Froment-Meurice stand at the Products of Industry Exhibition in 1849. A number of pieces can be identified in the photograph: the monstrance and its stand (see cat. 6) and the two reliquaries made for the Church of La Madeleine; the epergne belonging to the Duke of Luynes, which was commissioned in 1846 and took three years to make; the ewer and basin and one of the jewel caskets that were part of the toilet set ordered for the wedding of the Princess of Lucques, the future Duchess of Parma (Toiletry set in the Musée d'Orsay, OAO 530-535).

9. Louis Robert (Paris, France, 1810 – Sèvres, France, 1882), *Vue du stand de la manufacture de Sèvres à l'Exposition de 1855*, 1855 [View of the Manufacture de Sèvres stand at the 1855 Exhibition]. Salted paper print from a collodion glass negative, 31.7 x 23.9 cm. Plate 42 of the Watelin de Lummen album.
PHO 1984 98 42
Louis Robert took a series of photographs of the products of the Sèvres porcelain factory, where he headed the painting and gilding workshops, for the first great show of the Products of Art and Industry at the Universal Exhibition of 1855. These prints won critical acclaim at the second exhibition of the Société Française de Photographie, in 1857: "By the composition of the tableau, the arrangement of each object and above all by the distribution of the light, Mr. Robert has proved how great the share of the artist's intelligence and sensitivity still is, even when he is working on a still life."

Charles Nègre (Grasse, France, 1820 – 1880)

10. "*La Renommée chevauchant Pégase", sculpture d'Antoine Coysevox, place de la Concorde, à Paris*, 1859 ["Fame Riding Pegasus", a statue by Antoine Coysevox, Place de la Concorde, Paris]. Albumen print from an albumen glass negative, 44 x 35.4 cm. Gift of Mr. Joseph Nègre.
PHO 1981 18

In 1858, Charles Nègre, who had just developed the photogravure technique, considered publishing an illustrated book on Paris and its history. The project came to nothing and his plans for an illustrated history of world art also fell through. To encourage him, the Director of the Fine Arts Department, Frédéric de Mercey, commissioned a monograph on the statues of the Tuileries Palace. Nègre set to work in June 1859 and took thirty photographs, submitting the prints to the Fine Arts Department for approval. But he was again disappointed; Mercey fell ill (he died in 1860) and his successor dropped the project.

11. "*Le Silence" ou "Le Mystère de la mort", sculpture d'Auguste Préault*, 1858 ["Silence" or "The Mystery of Death", a sculpture by Auguste Préault]. Black ink photogravure, 36.6 x 32.4 cm. Gift of Monsieur Joseph Nègre.
PHO 1981 17

This photogravure, made by Nègre from a photograph perhaps taken by someone else, shows a medallion by Auguste Préault (1809–79), intended for the grave of Jacob Roblès (1782–1842) in the Jewish cemetery at Père Lachaise. Nègre added a decor of stars around this "really terrible work that the heart can hardly bear to contemplate, which seems to have been carved with death's great chisel" (Jules Michelet, 1846).

12. Benjamin Delessert (Paris, France, 1817 – 1868), "*La Cène", gravure de Marc-Antoine Raimondi d'après Raphaël*, ca 1853 ["The Last Supper", an engraving by Marcantonio Raimondi after Raphael]. Salted paper print from a paper negative, 28.6 x 42.6 cm.
PHO 1979 19

In 1853, Goupil published *Notice sur la vie de Marc-Antoine Raimondi, graveur bolonais, accompagnée de reproductions photographiques de quelques-unes de ses estampes, par Benjamin Delessert*. Wanting to share his passion for the arts, the photographer, who also appreciated and collected prints, reproduced sixty-five plates by Marcantonio Raimondi (ca 1480–between 1527 and 1534), who had worked under the influence and guidance of Raphael. One of his engravings probably inspired Édouard Manet's *Le Déjeuner sur l'herbe*.

Gustave Le Gray (Villiers-le-Bel, France, 1820 – Cairo, Egypt, 1884)

13. *Vue du Salon de 1850-1851*, 1851 [View of the Salon of 1850–51]. Salted paper print from a paper negative, 16.5 x 25.2 cm.
PHO 1984 104 9

Works that can be recognised, from left to right: *La Jeune Hero* or *Nyssia*, by Antoine Etex; *Jeune fille*, by Jean-Louis-Nicolas Jaley; *Faune dansant*, by Eugène Lequesne; *Une heure de la nuit*, by Joseph-Michel-Ange Pollet and *La Toilette d'Atalante*, by James

Pradier. The sculpture on the right in the background has not yet been identified. This photograph was put at the back of an album of views of the 1852 Salon commissioned from Le Gray by Philippe de Chennevières, Inspector of Provincial Museums and in charge of exhibitions of the work of living artists.

14. *Salon de 1852, Grand Salon mur nord*, 1852 [Salon of 1852, Grand Gallery, North Wall]. Salted paper print from a paper negative, 18 x 21.6 cm.
PHO 1983 167

This is the second photograph in the album devoted to the 1852 Salon, which was held for the second and last time in the Palais Royal (see cat. 13). All the paintings have been identified. We shall name only those most clearly visible. In the top row, the two large canvases seen front-on are respectively, left, *Tout passe*, by Omer-Charlet, and, right, *Satan foudroyé*, by Charles Lefebvre. In the middle row, centre, is Gustave Courbet's painting *Les Demoiselles de village*. At the bottom, two small landscapes by Théodore Rousseau flank a portrait of a woman in a medallion by Ange Tissier.

15. William Henry Fox Talbot (Melbury Abbas, England, 1800 – Lacock, England, 1877), *Porcelaines de Chine sur des étagères*, ca 1844 [Pieces of Chinese Porcelain on Shelves]. Salted paper print from a negative calotype, 13.9 x 18 cm. Gift of the Kodak-Pathé Foundation.
PHO 1983 165 92

The Pencil of Nature was the first book to be illustrated with photographs. Between June 1844 and April 1846, Talbot chose twenty-four photographs (views of buildings, photogenic drawings, collections of objects, reproductions of works of art) which he published in six parts, each image accompanied by an explanatory text. These pieces of Chinese porcelain on four shelves figure as no. 3 in part 1.

16–17. Gustave Le Gray, *Vues du Salon de 1853*, 1853 [Views of the Salon of 1853]. Salted paper prints from dry waxed negatives, respectively 25.2 x 35.5 and 23.4 x 32.9 cm.
PHO 2000 13 2 and 3

It is not known whether Chennevières commissioned Le Gray, as he had the previous year, to take these views of the Salon of 1853, held that year in the Hôtel des Menus Plaisirs, rue du Faubourg-Poissonnière, or whether the photographer acted on his own initiative. In the first photograph, we can see, on the left-hand wall, two paintings by Gustave Courbet, *Les Lutteurs* and *Les Baigneuses*, as well as *La Jeune Fille cosaque trouve Mazeppa évanoui sur le cheval sauvage mort de fatigue* by Théodore Chassériau. The back wall is devoted to three large murals by Paul Chenavard for the Pantheon: *Commencement de la Réforme*, *Attila* and *Auguste ferme les portes du temple de Janus*. Among the sculptures, we see *Le Dévouement* by Antoine Etex, *Statue équestre du duc Charles de Lorraine, gouverneur des Pays-Bas* by Joseph Jaquet and *Cheval attaqué par un lion* by Christophe Fratin. On the left-hand wall in the second photograph, *Deux anges en adoration devant la couronne d'épines*, by Adolphe Croneau and *Idylle* by Jean-Léon Gérôme. Among the sculptures we see *La Vierge à l'enfant* by Gustave Évrard, *Didon* by Alexandre Renoir, *Les Lutteurs* by Ottin, *La Vérité* by Pierre-Jules Cavelier (now in the Musée d'Orsay: RF 12), and *Zèbre attaqué par une panthère* by Isidore Bonheur.

18. Victor Laisné and Émile Defonds (active in the 1850s), *Sa majesté l'Impératrice des Français, d'après le buste de Mr le comte de Nieuwerkerke*, 1853 [Her Majesty the Empress of the French, after the Bust by the Count of Nieuwerkerke]. Salted paper print, 29.2 x 19.3 cm.
PHO 1985 418
This photograph is in the album *Souvenirs photographiques*, published by Blanquart-Évrard in 1853. For one of their first joint projects, Laisné and Defonds chose the bust of Eugénie (1826–1920), the wife of Emperor Napoleon III (1808–73), by Count Alfred-Émilien de Nieuwerkerke (1811–92), of which the Musée d'Orsay has a plaster version (RF 2438).

19. Disdéri Studio or Désiré (1809–1874) **or Edmond Lebel** (1834–1908), *"Portait du prince Napoléon, de profil, en médaillon" de Jean Auguste Dominique Ingres*, 1855 ["Portrait of Prince Napoleon, side view, medallion" by Jean Auguste Dominique Ingres]. Albumen print from a glass negative, 38 x 28 cm.
PHO 2006 2 1
This portrait of Prince Jérôme Napoléon (1822–91) by Ingres (1780–1867) was hung in the room dedicated to the artist at the Universal Exhibition of 1855. It is not mentioned in the catalogue but it is clearly recognisable in the photographs of the works hung in the Ingres room. Recorded as destroyed in the fire that devastated the Palais Royal in 1871, it was known through an engraving by Victor Florence Pollet (1811–82), in which the frame was not reproduced. A study for the frame, in pencil, is in the Musée Ingres, Montauban. This photograph, which came to the Musée d'Orsay with the papers of the

painter Edmond Lebel, is a valuable testimony to the work in its frame of gilt wood or plaster, surmounted by the imperial eagle.

20–21. Charles Marville (Paris, France, 1816 – ca 1879), *"Arabe d'El Aghouat"* and *"Nègre du Soudan", sculptures de Charles Cordier*, 1858 ["Arab from El Aghuat" *and* "Negro from the Sudan", sculptures by Charles Cordier]. Albumen prints from glass negatives, respectively 21 x 12 and 20.8 x 15 cm.
PHO 1991 16 1 and 14
Between 1850 and 1856, the sculptor Charles Cordier (1827–1905) was asked by successive directors of the Fine Arts Department to execute some twenty busts representing various "types of human races", with a view to opening an anthropology gallery. Keen to promote his work, Cordier asked Charles Marville to photograph his sculptures. The photographer collected twenty-three prints of nineteen busts in an album which was his first publication of the work of a contemporary artist. Cordier's polychrome sculptures served as a model for these two prints which are respectively in the Musée d'Orsay (RF 3598) and the Musée de Compiègne (on permanent loan from the Musée d'Orsay, RF 3599).

Robert Jefferson Bingham (?, England, 1825 – Brussels, Belgium 1870)

22. *"Lady Jane Grey au moment du supplice", tableau de Paul Delaroche (1833)*,1858 ["The Execution of Lady Jane Grey", painting by Paul Delaroche (1833), now in the National Gallery, London]. 17 x 20.7 cm.
PHO 1983 165 159 7

23. *"Lord Strafford allant au supplice", tableau de Paul Delaroche (1835)*, 1858 ["Lord Strafford on the Way to his Execution", painting by Paul Delaroche (1835), now in a private collection]. 17.4 x 21 cm.
PHO 1983 165 159 3

24. *"Hérodiade avec la tête de saint Jean-Baptiste", tableau de Paul Delaroche [1843]*, 1858 [Herodias with the Head of John the Baptist", a painting by Paul Delaroche (1843) now in the Wallraf-Richartz Museum, Cologne]. 15 x 11 cm.
PHO 1983 165 159 37

25. *"Les Joies d'une mère", tableau de Paul Delaroche (1843)*, 1858 ["A Mother's Joy", a painting by Paul Delaroche (1843), now in the Musée J.B. Pescatore, Art Gallery of the City of Luxembourg]. Diameter 16.5 cm.
PHO 1983 165 159 22

Albumen prints from collodion glass negatives. Gift of the Kodak-Pathé Foundation.
Robert Bingham took part in the Universal Exhibition in London in 1851, both as an exhibitor and as a photographer commissioned to make prints to illustrate the jury's report. In 1855, he was sent to the Universal Exhibition in Paris and incidentally commissioned to photograph the collections in the Louvre. He settled in France and worked for the first time with Goupil on the book *L'Œuvre de Paul Delaroche reproduit en photographie par Bingham accompagné d'une notice sur la vie et les ouvrages de Paul Delaroche par Henri Delaborde et du catalogue raisonné de l'œuvre par Jules Goddé*. The photographs were taken by Bingham at a posthu-

mous exhibition of Delaroche's work (1797–1856) held at the École des beaux-arts in 1857. The book, including eighty-six plates, was the first catalogue raisonné of the work of a contemporary artist to be illustrated by photographs.

26–27. Louis-Émile Durandelle (Verdun, France, 1839 – Bois-Colombes, France, 1917), *Masques des cheminées des bâtiments de l'administration* and *Masques du vestibule circulaire, Le Nouvel Opéra de Paris*, 1875 [Masks on the Mantelpieces of State Buildings *and* Masks in the Circular Lobby, in the New Opera House, Paris]. Albumen prints from collodion glass negatives, respectively 28 x 38.2 and 21 x 27.7 cm.
PHO 1986 134 39 and 36
"To keep a record of the various stages in the construction of the Opera House, *photographs* were taken whenever major changes were made on the building site […]. If, at a later date, we decide to produce a monograph on the Opera, the *photographic documents* we will have accumulated will greatly facilitate the publication", the architect Charles Garnier (1825–98) noted in his report on the work on the new opera house in 1866. The monograph was indeed published by Ducher et Cie. It is composed of two volumes of texts by Garnier, two volumes of engraved plates and chromolithographs of the outside of the building and four volumes of photographs by Durandelle: *Sculpture ornementale, Statues décoratives, Peintures décoratives* and *Bronzes*.

28. Disderi Studio with Désiré (1809 – 1874) or **Edmond Lebel** (1834 – 1908), *Planche avec huit sculptures de femme allongée*, ca 1860 [Plate with

Eight Sculptures of a Reclining Woman]. Albumen print, 26.5 x 20 cm.

PHO 2006 2 2

The studio papers of the painter Edmond Lebel, recently acquired by the Musée d'Orsay, show the artist's close involvement with photography. His father, Désiré, a lithographer, went into partnership with Eugène Disdéri (1819–89) in the early 1860s, then opened his own studio in order to help his son. Edmond took photographs himself, bought the work of others and used photography as a preparatory stage for his paintings. The presentation of this plate, which shows the same motif eight times over, brings to mind the visiting card process developed by Eugène Disdéri.

29. Ad. Braun & Cie (1876 – 1889), or **Maison Ad. Braun & Cie. Braun Clément & Cie Successeurs** (after 1889), *Musée du Louvre, la salle de Michel-Ange,* between 1883 and 1896 [Michelangelo Room in the Louvre]. Albumen print from a collodion glass negative, 47 x 37.5 cm.

PHO 1991 12 217

Here we see *The Portal of the Stanga Palace*, which entered the Louvre in 1876, and *Slaves* by Michelangelo (1475 – 1564) in a gallery in the Louvre, with a low relief of the *Virgin and Child* above each *Slave*. In the doorway leading to the "small Italian gallery" is a bronze bust of a Roman emperor, attributed to Ludovico Lombardi.

30–31. Pierre-Ambroise Richebourg, *Vues du Salon de 1857,* 1857 [Views of the Salon of 1857]. Albumen prints, each 22 x 32.5 cm.

PHO 2000 13 6 and 7

Richebourg, a familiar of the imperial court, was appointed official photographer at the Salon of 1857, held for the first time in the Palais de l'Industrie. In the first photograph we see, at the bottom, *Portrait en pied de S. M. l'Impératrice tenant sur ses genoux le prince impérial* painted by Franz Xaver Winterhalter, and in the second, top centre, *Arrivée de S. M. la Reine d'Angleterre au palais de Saint-Cloud* by Charles-Louis Muller.

32–33. Théodule Devéria (Paris, 1831 – 1871), *Saqqarah – Neuf ivoires grecs* and *Fouilles du Serapeum de Memphis – Statue de lion*, 1859 [Saqqarah – Nine Greek Ivories *and* Excavation of the Serapeum of Memphis – Statue of a lion]. Salted paper prints from paper negatives, respectively 21.5 x 27 and 21 x 26 cm.

PHO 1986 144 57 and 62

In 1851, Auguste Mariette (1821–81) discovered the Serapeum of Memphis about thirty kilometres south of Cairo, at Saqqarah. Théodule Devéria, curator in the Department of Egyptian Antiquities at the Louvre since 1855, accompanied him on a new campaign of excavations which started in December 1858. He brought back a fund of photographs of excavated works as well as landscapes and portraits. (Despite the caption *Greek Ivories* on the negative, the statuettes are probably made of bone).

34–35. Pierre-Ambroise Richebourg, *Vues intérieures du pavillon chinois de l'impératrice à Fontainebleau*, 1863–70 [Interior Views of the Chinese Pavilion of the Empress at Fontainebleau]. Albumen prints from collodion glass negatives,

respectively 27.5 x 30 and 29.3 x 30.8 cm. Permanent loan from the Mobilier national to the Musée d'Orsay.
DO 1979 55 and 56

In 1863, the Empress Eugénie had four rooms refurbished on the ground floor of the Palace of Fontainebleau, one of which was to house objets d'art from the Far East brought back from China after the pillage of the Summer Palace during the Franco-English expedition in 1860, or gifts from the Siamese ambassadors received at Fontainebleau in 1861. Richebourg's photographs are a valuable record of the refurbishing of this "Chinese Museum" which remained in place until the end of the Empire. Redecorated and opened to the public until 1975, it has since been entirely restored. In 1991, it was brought very close to its original state.

Léon Vidal (?, 1833 – ?, 1906) and **Paul Dalloz** (?, 1829 – ?, 1887)

The preparation of *Trésor artistique de la France*, published by Paul Dalloz in 1878, the first work illustrated with colour photographs using the photochromy process developed Léon Vidal, sparked long and lively debates in the administration of the Louvre. The risks incurred by the presence of the photographers, with their equipment and their chemicals, and the displacement of the works for the photographs to be taken, were discussed in a long exchange of letters. Permission was finally granted and thirty-eight plates were made of objets d'art selected from the Apollo Gallery. A text by the critic Paul Mantz (1821–95) was published with the photographs.

36. *Coupe en sardoine onyx orientale, XVIᵉ siècle*, 1876 [Oriental Sard Onyx Cup, 16th century]. Photo-mechanical print (photochrome), 20.8 x 26.2 cm. Plate 1 of volume 6. Gift of the Kodak-Pathé Foundation.
PHO 1983 165 539 1

There are lingering doubts about the provenance of this sard cup; the original gold, enamel and ruby base has been replaced by a gilt copper stand in the shape of a baluster.

37. *L'Aigle de l'abbé Suger*, 1876 [Abbot Suger's Eagle]. Photomechanical print (photochrome), 31.6 x 21.5 cm. Plate 2 of volume 12. Gift of the Kodak-Pathé Foundation.
PHO 1983 165 544 2

Abbot Suger (1081–1151) discovered an antique porphyry vase, perhaps Egyptian, among the treasures of the Abbey of Saint Denis. He decided to embellish it and use it during religious ceremonies. A silver gilt mount turned the antique vase into an eagle.

Adolphe Braun (Besançon, France, 1812 – Dornach, France, 1877)

38. *Rome, palais du Vatican, chapelle Sixtine, fresque de Michel-Ange : "Dieu créant l'homme"* [Rome, Vatican Palace, Sistine Chapel, fresco by Michelangelo: "God Creating Man"] detail.

39. *Rome, palais du Vatican, chapelle Sixtine, fresque de Michel-Ange : "Dieu créant le soleil et la lune"* [Rome, Vatican Palace, Sistine Chapel, fresco by Michelangelo: "God Creating the Sun and the Moon"].

40. *Rome, palais du Vatican, chapelle Sixtine, fresque de Michel-Ange : "Sybille lybienne".* [Rome, Vatican

Palace, Sistine Chapel, fresco by Michelangelo: "Libyan Sibyl"].

41. *Rome, palais du Vatican, chapelle Sixtine, fresque de Michel-Ange : "Sybille de Delphes"* [Rome, Vatican Palace, Sistine Chapel, fresco by Michelangelo: "Delphic Sibyl"].

1869. Carbon prints, respectively 37 x 50; 38.5 x 48.5; 47.8 x 38 and 47.8 x 36.5 cm.
PHO 1991 12 145, 148, 139 and 140
From 1866, Braun used the carbon process to reproduce large prints of art works for schools, libraries, museums, artists and art lovers. In 1868, on the advice of the critic Paul de Saint-Victor (1827–81), he undertook a photography campaign in European museums, starting with Italy. Between February and October 1869, he obtained four permits to take photographs inside the Vatican.

42. *Florence, "Vierge à l'enfant", sculpture de Michel-Ange*, 1868 [Florence, Virgin and Child, sculpture by Michelangelo]. Carbon print, 46 x 34.5 cm.
PHO 1991 12 142
Braun started his tour of Italian museums with Florence, Venice and Milan.

43. Charles Marville, *"Moïse" sculpture de Michel-Ange, église Saint-Pierre-aux-Liens à Rome*, ca 1861 ["Moses", sculpture by Michelangelo, Church of St Peter in Chains, Rome]. Albumen print from a glass negative, 33.7 x 24.5 cm.
PHO 1991 12 166
In 1861, Marville was sent to Italy on a state commission to reproduce the drawings of the masters in the museums of Turin and Milan, designed to enrich the collections of art schools in France. At the time, Marville was the only photographer admitted to the Louvre, and, although the title was not official, he wrote "Photographer of the Imperial Museum of the Louvre" on his prints.

44. Adolphe Braun, *Florence, "Vierge à l'enfant", dessin d'Andrea Mantegna [1431–1506]*, 1868 [Florence, "Virgin and Child", drawing by Andrea Mantegna (1431–1506)]. Carbon print, 28 x 17.5 cm.
PHO 1991 12 143

45. Ad. Braun & Cie, *Madrid, musée du Prado, Portrait d'un cardinal, tableau de Raffaello Sanzio [1483–1520]*, 1881 [Madrid, Prado, Portrait of a Cardinal, painting by Raffaello Sanzio (1483–1520)]. Carbon print, 45 x 35 cm.
PHO 1991 12 156
Bearing the stamp "Ad. Braun & Cie", the photographs taken in Madrid are probably the work of Gaston Braun (1845–92), Adolphe's son (the firm's name appeared in 1876, Adolphe died the following year, and his other son, Henri, died in 1876). Over two thousand works were photographed during their campaign in the Prado, in 1881.

46. Stephen Thompson (?, 1830 – ?, 1893), *Le Nil (Vatican, Rome)*, 1878 [*The Nile (Vatican, Rome)*]. Carbon print, 21 x 15.5 cm. Plate 21 in *Masterpieces of Antique Art*, published by Griffith and Farran in London. Gift of the Kodak-Pathé Foundation.
PHO 1983 165 533 21
Published in 1878, *Masterpieces of Antique Art* assembled twenty-five photographs of sculptures in

the Vatican, the British Museum or the Louvre. This allegory of the Nile is a Roman work dating from the first century AD, no doubt after a Hellenistic model, and was placed in a temple dedicated to Isis and Serapis. Discovered in 1513 near Santa Maria Sopra Minerva in Rome, it is now in the Braccio Nuovo of the Vatican museum. It had been sent to France, following the Treaty of Tolentino (1797) with its pendant, *The Tiber*. Although *The Nile* was given back after Waterloo, it was agreed that *The Tiber* would stay in the Louvre (MR 356).

47. Charles Roettger, *"Madonna Litta", tableau de Léonard de Vinci*, ca 1870 ["Madonna Litta", a painting by Leonardo da Vinci]. Albumen print, 22.6 x 17.8 cm.
PHO 1991 12 272
This *Virgin and Child* painted about 1490 by Leonardo da Vinci (1452–1519), was called the *Madonna Litta* after its last owner, who sold it to the Hermitage Museum in St Petersburg in 1866. According to the note on the frame, it was photographed "after the original with the permission of His Majesty the Emperor, by Charles Roettger, bookseller to the imperial court", then distributed by Goupil.

48–49. Anonymous, *Amenamhat II en costume de prêtre (musée de Boulaq)*, after 1862 [Amenemhat II Dressed as a Priest (Bulaq Museum)] and *Salle de l'ancien empire avec une statue du prêtre Ranefer (musée de Boulaq)*, after 1860 [Old Kingdom Room with a Statue of the High Priest Ranefer (Bulaq Museum)]. Albumen prints from glass negatives, respectively 23.3 x 18 and 18.2 x 23.3 cm.
PHO 1986 142 32 and 50

The Musée d'Orsay has three albums bearing the inscription "Mission Ad. M. Cattaui" on the spine. Adolphe Cattaui (1865–1925) was sent on a mission to Egypt in 1886, where he probably collected existing prints which he later put together in a series of albums. The first two contain photographs of landscapes and Egyptian monuments, the third reproductions of works such as this statue of Amenemhat II, discovered in 1862 on the site of Medinet el Fayum, and that of the high priest Ranefer, found at Saqqarah by Mariette in 1860. Some of the photographs in the first two albums are signed H. Béchard (Henri Béchard, a French photographer believed to have worked in Egypt from the late 1860s to the late 1880s) and have a caption on the negative; others, in a smaller size, are unsigned. The photographs in the third album are unsigned, except for three which bear the signature of É. Béchard and match the list of plates in the *Album du Musée de Boulaq* produced in 1871 by Hippolyte Délié and Béchard with an explanatory text by Mariette. Perhaps the signatures "H" and "E" Béchard refer to one and the same person.

50–51. Séraphin Médéric Mieusement (Gonneville-la-Mallet, France, 1840 – Pornic, France, 1905), *Tombeau antique au musée d'Arles*, 1888 [Ancient Tomb in the Musée d'Arles] and *Guerrier gaulois au musée Calvet, Avignon*, ca 1890 [Gallic Warrior in the Musée Calvet, Avignon]. Albumen prints, respectively 25 x 36.4 and 36 x 25.2 cm. Gift of M. Courajod.
PHO 1991 13 119 and 115
The Museum of Comparative Sculpture opened at the Trocadero in 1882, on the initiative of Eugène-

Emmanuel Viollet-le-Duc (1814–79). Mieusement, who had been working since 1875 for the Historic Monuments Commission, was approached to build up a collection of photographs intended to complement the museum's collection of plaster casts. In 1883, he secured a contract which also gave him the monopoly of sales at the museum.

52–53. Jean (Juan) Laurent (Garchizy, France, 1816 – Madrid, Spain, 1892), *Fragments de style arabe-byzantin trouvés sur l'emplacement de Medina-az-Zaharà* and *Salle de la section arabe. Cordoue, musée provincial*, ca 1870 [Fragments in Arab-Byzantine style found on the site of Medina-az-Zahara *and* Room in the Arab Section. Cordoba, Provincial Museum]. Albumen prints, respectively 23.7 x 33 and 31.9 x 24.3 cm.
PHO 2004 1 37 and 78
Reproductions of art works hold a significant place in the prolific work of Juan Laurent, a French photographer who settled in Spain in 1857. In particular, he published *L'Œuvre de Velázquez au musée du Prado*. After he died, José Lacoste, who succeeded him under the name of Laurent y Cia, exploited his archives which contained fifty thousand negatives, including a veritable photographic inventory of Spanish museums.

54–55. Clément & Cie Braun (Paris, France, between 1889 and 1910), *"Sur une plage déserte, les Troyennes pleuraient la perte d'Anchise, et, pleurant, elles regardaient la mer profonde", tableau de Théodore Chassériau (1840–1841)*, 1890 ["On a deserted beach, the Trojan women wept over the death of Anchises, and as they wept they gazed at the deep sea", painting by Théodore Chassériau

(1840–1841)] and *"Les Vendangeurs", fragment du décor peint par Théodore Chassériau pour le bâtiment de la Cour des comptes (entre 1844 et 1848)*, 1890 ["The Grape Pickers", fragment of a decoration painted by Théodore Chassériau for the Audit Office (between 1844 and 1848)]. Carbon prints, each 39 x 49 cm.
PHO 2001 7 16 and 12
The murals painted by Théodore Chassériau (1819–56) for the Audit Office in 1844–48 were mostly destroyed by fire during the Commune in 1871. Only a few fragments survived, behind the protective stays visible in the fragment of the *Grape Pickers* presented here. They have since been sent to the Louvre. In 1890, the Chassériau committee commissioned Braun et Cie to make a photographic reportage of this mural on the site of the future Orsay railway station, later the Musée d'Orsay. The painting *The Trojan Women*, also photographed by Braun et Cie, was destroyed in Budapest in 1945, along with other pieces in the Baron Hatvany collection.

Charles and/or **G. Michelez** (active in Paris, France, between 1856 and 1901)
Every year from 1864 to 1901, the Department of Fine Arts had a set of albums made of photographs of works that had been commissioned or bought by the state at the Salon. Until 1886, a few plates giving an overall view of the presentation of the sculptures were included at the back of each album.

56. *Salon de 1872, vue générale du jardin et de la sculpture (côté gauche)*, 1872 [Salon of 1872, General View of the Garden and Sculptures (left)]. Albumen print, 25.2 x 37.2 cm. Leaf 25 in the album.

PHO 1991 12 56

Works identified on this print: *Les Quatre Parties du monde soutenant la sphère* by Jean-Baptiste Carpeaux (plaster group now in the Musée d'Orsay, RF 817), *La Bocca della Verita* by Jules Blanchard, *David* by Antonin Mercié (plaster model for the bronze now in the Musée d'Orsay, RF 186), *Pierre Corneille* by Alexandre Falguière, *Marguerite après sa faute* by Émile Boisseau, *Jeanne d'Arc à Domrémy* by Henri Chapu (in the Musée d'Orsay, RF 166), *La Jeune Tarentine* by Alexandre Schoenewerk (in the Musée d'Orsay, RF 215).

57. *Tableaux acquis par l'État au Salon de 1879*, 1879 [Paintings Purchased by the State at the Salon of 1879]. Albumen print, 27 x 36 cm. Leaf 6 in the album. Musée d'Orsay library.
The painting by Émile Renard and *Naissance de Vénus* by William Bouguereau were bought for the Musée du Luxembourg, and the latter is now in the Musée d'Orsay (RF 253). The work by Georges Moreau de Tours was bought for the Musée du Mans, that by Renouf for the Musée d'Issoudun, and that by Salmson for the Musée d'Amiens. The destination of Paul Langlois' *Persée et Méduse* is unknown.

58. *Salon de 1882. Jardin. Sculpture. Côté droit*, 1882 [Salon of 1882. Garden. Sculpture. Right side]. Albumen print, 24 x 37 cm. Leaf 36 in the album. Musée d'Orsay library.
Works identified on this print: *Derniers moments de Molière* by Henri Allouard, *Le Saut de la haie* by Isidore Bonheur, *Camille Desmoulins au Palais-Royal* by Albert-Ernest Carrier-Belleuse, *Étienne-le-Grand, prince de Moldavie* by Emmanuel Fremiet, *L'Amour piqué* by Jean-Marie Idrac (at the Musée d'Orsay, RF 3997), *L'Âge de fer* by Alfred Lanson (on permanent loan to the town hall of Commentry, RF 568) and *M. de Sacy* by Louis Marin.

59. Anonymous, *Musée du Luxembourg, salle des sculptures*, between 1897 and 1901 [Musée du Luxembourg, Sculpture Room]. Albumen print, 28.8 x 40 cm.
PHO 1991 12 218
Dedicated to living artists since 1818, the Musée du Luxembourg moved in 1886 from the palace itself to the Orangery, to which a new wing was added to house sculptures. Apart from the two sculptures in the foreground – *Galatée* by Laurent-Honoré Marqueste, 1885, and *Salammbô* by Jean-Marie Idrac, 1882 – we will mention those which are now in the Musée d'Orsay: *Pan et oursons* by Emmanuel Fremiet, 1867 (RF 178), *Mercure inventant le caducée* by Jean-Marie Idrac, 1878 (RF 301), *Souvenir* by Antonin Mercié, a replica of a marble in 1885 (RF 2513), *Hébé endormie* by Carrier-Belleuse, 1869 (RF 163) and *Une trouvaille à Pompéi* by Hippolyte Moulin, 1863 (RF 190).

60–61. Alfred Stieglitz (Hoboken, New Jersey, 1864 – New York, 1946), *Brancusi Sculpture, March 1914* and *Nadelman Exhibition—2 Rooms, December*. Photomechanical prints (half-tone process), *Camera Work* 48, October 1916. Each plate 11 x 14 cm. Gift of Minda de Gunzburg through the Société des Amis du Musée d'Orsay.
PHO 1981 34 11 and 14
In the gallery he ran in New York from 1905 to 1917, Stieglitz showed more than the photographs

of his friends in the Photo Secession. He quickly opened his doors to avant-garde American painters and put on the first exhibitions in America of French artists or artists working in France: Rodin, Matisse, Picasso, Braque… In March 1914, the public had an opportunity to see the work of Constantin Brancusi (1876–1957) through *Mademoiselle Pogany*, *Muse endormie*, *Maiastra*, *Danaïde* and *Le Premier Pas*. The body of the latter sculpture was destroyed after this first exhibition and the head continued its life alone. At the end of the following year, Elie Nadelman (1882–1946), a Polish artist who had recently moved to New York after ten years in Paris, filled two rooms in the gallery. *L'Homme en plein air*, right on the photograph taken by Stieglitz, is now in the Museum of Modern Art, New York.

62. Stephen Thompson, *Ariane endormie (Vatican, Rome)*, 1878 [Ariadne Asleep, Vatican, Rome]. Carbon print, 20.8 x 15.8 cm. Plate 18 of *Masterpieces of Antique Art*, published by Griffith and Farran in London. Gift of the Kodak-Pathé Foundation.
PHO 1983 165 533 18
This copy of *Ariadne Asleep*, executed in the second century AD from a Hellenistic original (from Pergamum) is now in the Pio-Clementino museum. For several centuries, because of the snakelike bracelet on her left arm, the statue was thought to represent Cleopatra. Research by the German and Italian archaeologists Winckelmann (1717–68) and Visconti (1751–1818) led to its now accepted identification as Ariadne.

Selected Bibliography

BANN, Stephen. *Parallel Lines, Printmakers, Painters and Photographers in 19th Century France*. New Haven, London: Yale University Press, 2001.

——. "Photographie et reproduction gravée. L'économie visuelle au XIXe siècle" in *Études photographiques*, no. 9 (May 2001): 22–43.

BOYER, Laure. *La Photographie de reproduction d'œuvres d'art au XIXe siècle en France, 1839–1919*, doctoral thesis, Institut d'Histoire de l'Art, Université Marc Bloch, Strasbourg, 2004 (unpublished).

——. "Robert J. Bingham, photographe du monde de l'art sous le Second Empire" in *Études photographiques*, no. 12 (November 1992): 126–47.

BRESC-BAUTIER, Geneviève (dir.), with Michèle Lafabrie. *Un combat pour la sculpture. Louis Courajod (1841–1896), historien d'art et conservateur*. Paris: Rencontres de l'École du Louvre, École du Louvre, 2003.

GAUTRAND, Jean-Claude and BUSINE Alain. *Blanquart-Évrard*. Douchy-les-Mines: Centre Régional de la Photographie Nord-Pas-de-Calais, 1999.

HAMBER, Anthony. *A Higher Branch of the Art*. London: Gordon and Beach Publishers, 1996.

JAMMES, Isabelle. *Blanquart-Évrard et les origines de l'édition photographique française. Catalogue raisonné des albums photographiques édités, 1851–1855*. Centre de Recherches d'Histoire et de Philologie de la IVe Section de l'École Pratique des Hautes Etudes. VI Histoire et Civilisation du Livre 12. Geneva, Paris: Librairie Droz, 1981.

LACAMBRE, Geneviève. "Un photographe au Salon de 1852" in *Hommage à Hubert Landais: art, objets d'art, collections*, pp. 197–204. Paris: Blanchard, 1987.

MCCAULEY, Ann. "Art Reproductions for the Masses" in *Industrial Madness*, pp. 265–300. New Haven, London: Yale University Press, 1994.

RENIÉ, Pierre-Lin. "Goupil et Cie à l'heure industrielle, la photo-graphie appliquée à la reproduction des œuvres d'art" in *État des lieux*, no. 1, pp. 89–114. Bordeaux: Musée Goupil, 1994.

——. "Braun *versus* Goupil et quelques autres histoires, la photographie au Musée du Louvre au XIXe siècle" in *État des lieux*, no. 2, pp. 97–151. Bordeaux: Musée Goupil, 1999.

RIONNET, Florence. *L'Atelier de moulage du Musée du Louvre (1794–1928)*, Notes et Documents des Musées de France, no. 28. Paris: Réunion des Musées Nationaux, 1996.

SAMOYAULT-VERLET, Colombe, Jean-Paul Desroches and Gilles Béguin, *et alii*. *Le Musée chinois de l'impératrice Eugénie*. Paris: Réunion des Musées Nationaux, 1994.

Exhibition Catalogues:

Charles Nègre photographe. Paris: Réunion des Musées Nationaux, 1980.

Auguste Préault, sculpteur romantique (1809–1879). Paris: Réunion des Musées Nationaux/Gallimard, 1997.

Paul Delaroche. Un peintre dans l'Histoire. Paris: Réunion des Musées Nationaux, 1999.

Gérôme et Goupil, art et entreprise. Paris: Réunion des Musées Nationaux, 2000.

Gustave Le Gray (1820–1884). Paris: Bibliothèque Nationale de France/Gallimard, 2002.

Théodore Chassériau, 1819–1856. Paris: Réunion des Musées Nationaux, 2002.

Le Daguerréotype français, un objet photographique. Paris: Réunion des Musées Nationaux, 2003.

Trésors d'argent. Les Froment-Meurice, orfèvres romantiques parisiens. Paris: Paris Musées, 2003.

Charles Cordier (1827–1905), l'autre et l'ailleurs. Paris: La Martinière, 2004.

New York et l'art moderne, Alfred Stieglitz et son cercle, 1905–1930. Paris: Réunion des Musées Nationaux/El Viso, 2004.

Adolphe & Georges Giraudon: une bibliothèque photo-graphique. Paris, Bourges: Somogy/Archives Départementales du Cher, 2005.

Plates

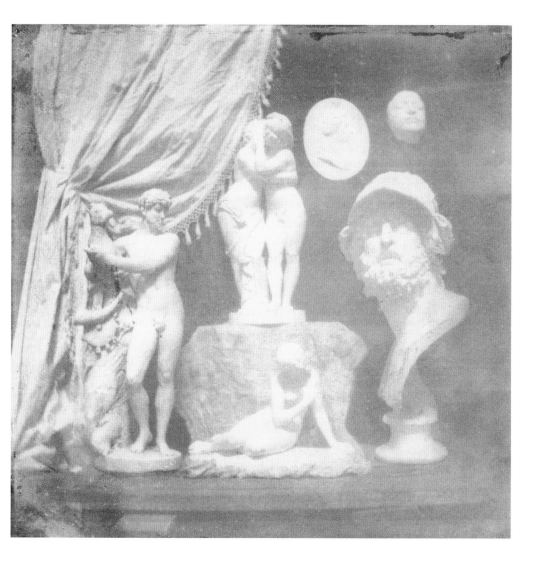

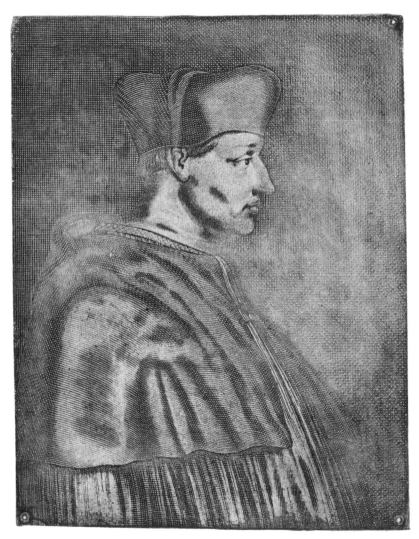

1. Hippolyte
Bayard
*Nature morte avec
moulages*
1839-1840

2. D'après Joseph
Nicéphore Niépce
*Le Cardinal
d'Amboise*
1869

3. Anonyme
« Sainte Barbe »,
dessin sur panneau
par Jean Van Eyck,
musée d'Anvers
ca 1850

4. Pierre-Ambroise Richebourg
*Élévations latérale et de la façade
d'une église néo-gothique, dessins
de l'architecte Hippolyte Durand*
ca 1845

5. Pierre-Ambroise Richebourg
Deux coupes du projet d'un même
édifice, dessins de l'architecte
Hippolyte Durand
ca 1845

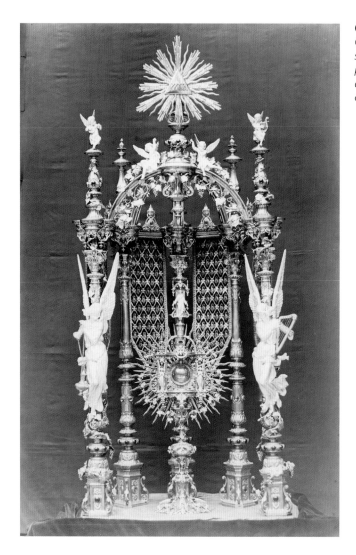

6. P. Allain
*Ostensoir et
son exposition
pour l'église
de la Madeleine*
ca 1876

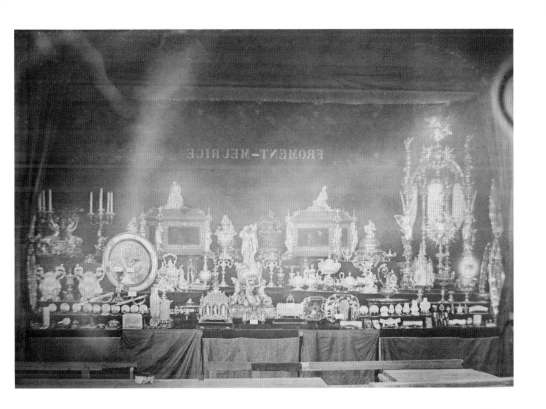

7. Pierre-Ambroise Richebourg
Présentation des œuvres
de Froment-Meurice
à l'exposition de 1849
1849

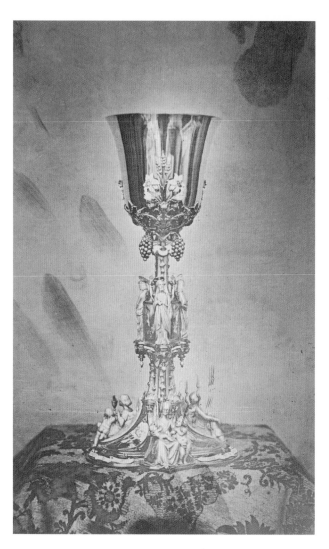

8. Pierre-Ambroise Richebourg
Coupe offerte par son Altesse Impériale le Prince Jérôme à son Altesse Impériale la Princesse Mathilde
ca 1858

9. Louis Robert
Vue du stand de la
manufacture de Sèvres
à l'Exposition de 1855
1855

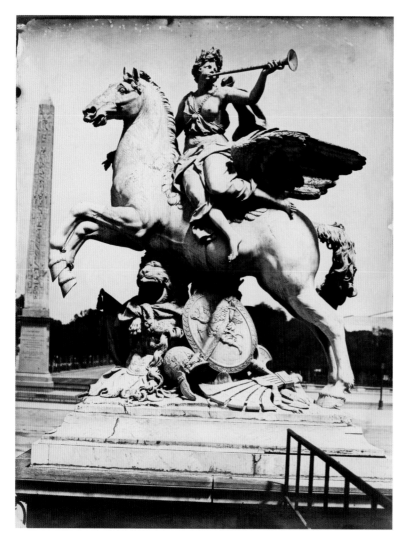

10. Charles Nègre
*« La Renommée
chevauchant Pégase »,
sculpture d'Antoine
Coysevox, place de
la Concorde, à Paris*
1859

11. Charles Nègre
*« Le Silence » ou
« Le Mystère de la
mort », sculpture
d'Auguste Préault*
1858

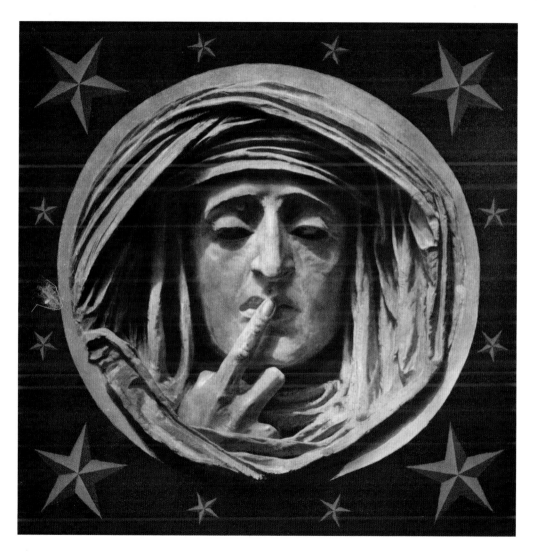

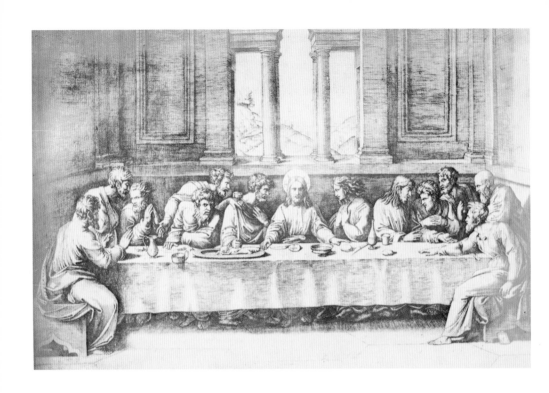

12. Benjamin Delessert
« La Cène », gravure de
Marc-Antoine Raimondi
d'après Raphaël
ca 1853

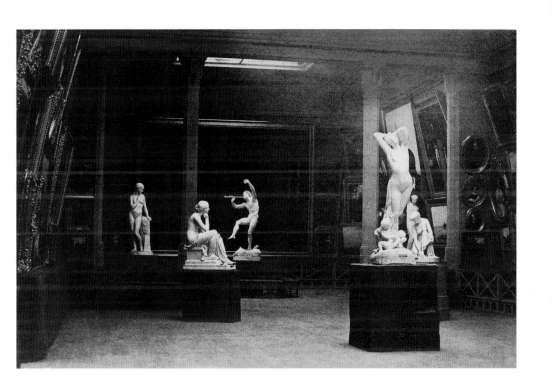

13. Gustave Le Gray
Vue du Salon de 1850-1851
1851

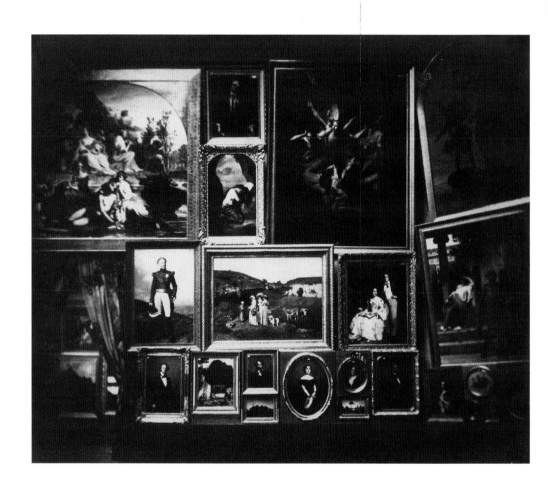

14. Gustave Le Gray
Salon de 1852, Grand Salon
mur nord
1852

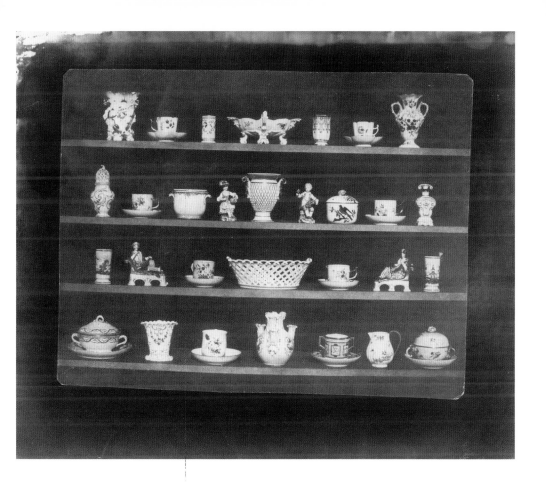

15. William Henry Fox Talbot
Porcelaines de Chine
sur des étagères
ca 1844

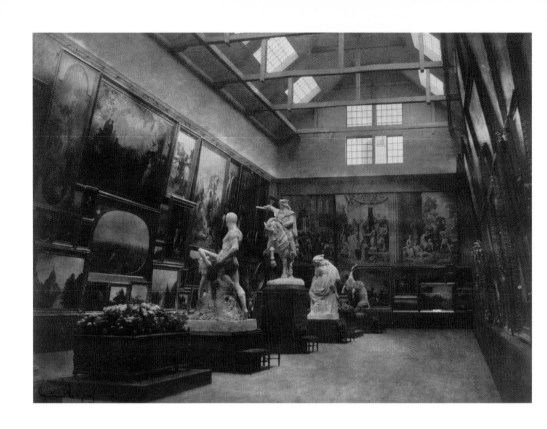

16. Gustave Le Gray
Vue du Salon de 1853
1853

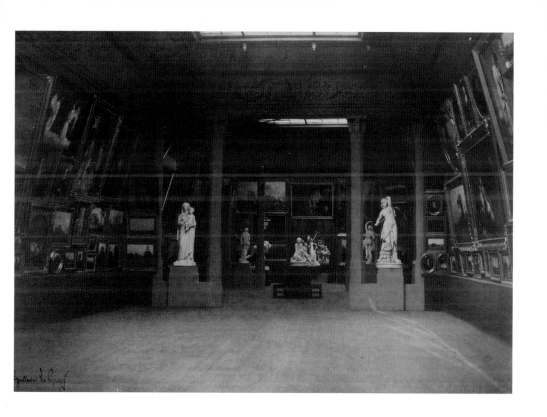

17. Gustave Le Gray
Vue du Salon de 1853
1853

**18. Victor Laisné
et Émile Defonds**
*Sa majesté l'Impératrice
des Français, d'après
le buste de Mr le comte
de Nieuwerkerke*
1853

**19. Atelier Disdéri
ou Désiré (1809-1874)
ou Edmond Lebel
(1834-1908)**
*« Portrait du prince
Napoléon, de profil,
en médaillon » de Jean
Auguste Dominique
Ingres (1780-1867)*
1855

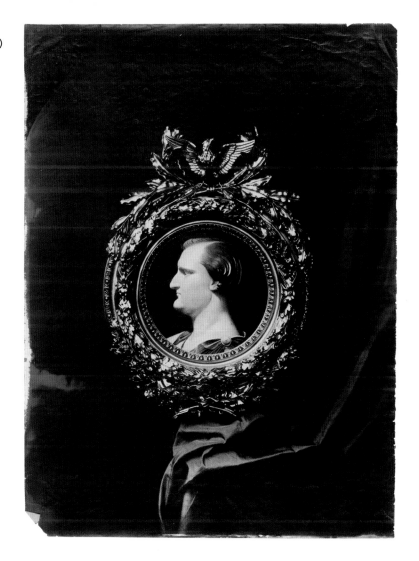

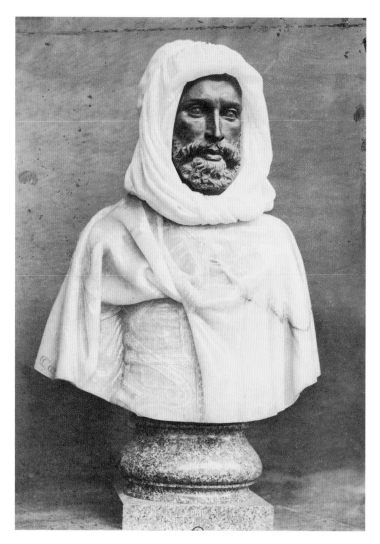

20. Charles Marville
*« Arabe d'El Aghouat »,
sculpture de
Charles Cordier*
1858

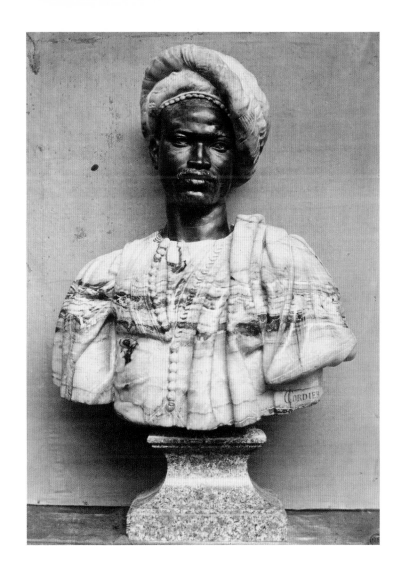

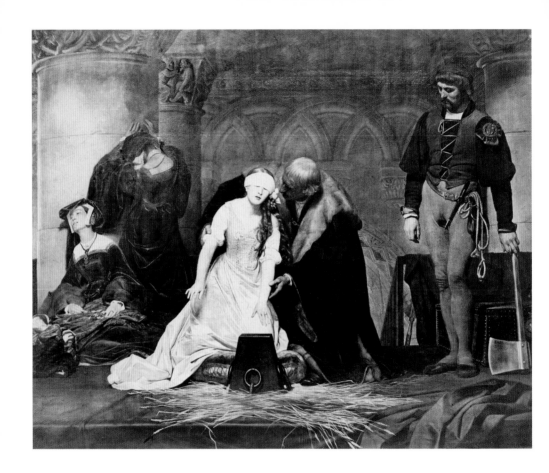

22. Robert Jefferson Bingham
« Lady Jane Grey au moment
du supplice », tableau
de Paul Delaroche (1833)
1858

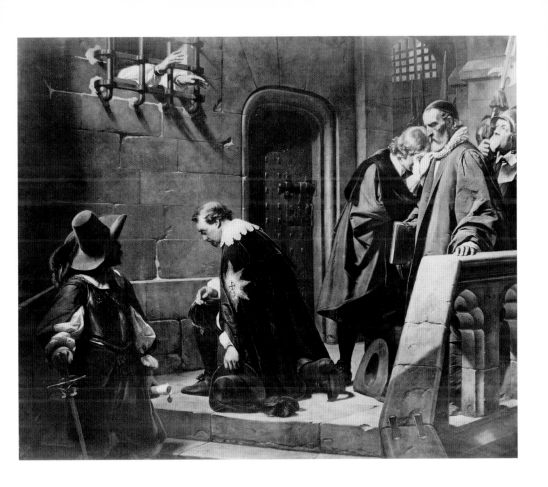

23. Robert Jefferson Bingham
« Lord Strafford allant au supplice »,
tableau de Paul Delaroche (1835)
1858

24. Robert Jefferson Bingham
*« Hérodiade avec la tête de saint Jean Baptiste »,
tableau de Paul Delaroche (1843)*
1858

25. Robert Jefferson Bingham
*« Les Joies d'une mère »,
tableau de
Paul Delaroche (1843)*
1858

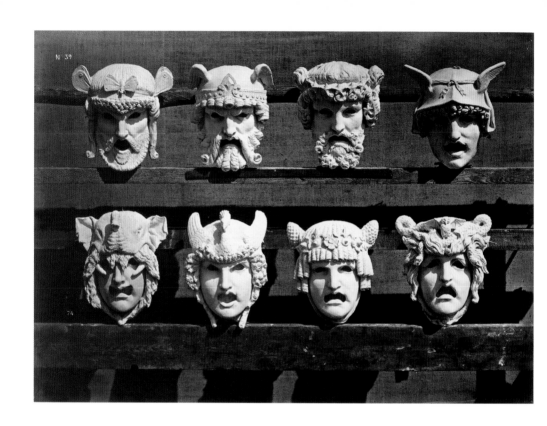

26. Louis-Émile Durandelle
*Masques des cheminées des
bâtiments de l'administration,
le Nouvel Opéra de Paris*
1875

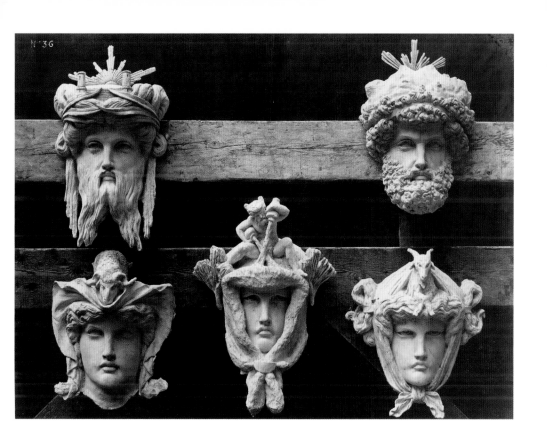

27. Louis-Émile Durandelle
Masques du vestibule circulaire,
le Nouvel Opéra de Paris
1875

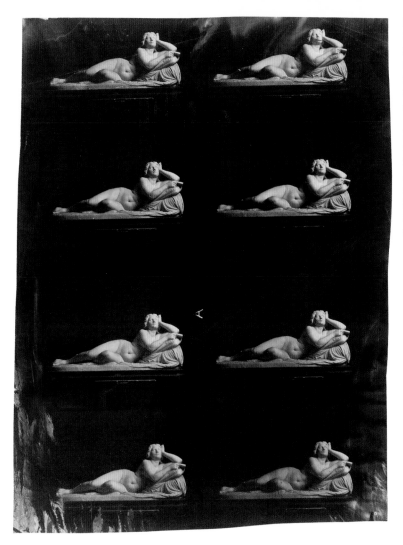

**28. Atelier Disderi
avec Désiré ou
Edmond Lebel**
*Planche avec
huit sculptures
de femme allongée*
ca 1860

**29. Ad. Braun & C^ie
(1876-1889), ou
Maison Ad. Braun
& C^ie. Braun
Clément & C^ie
Successeurs**
*Musée du Louvre, la
salle de Michel-Ange*
1883-1896

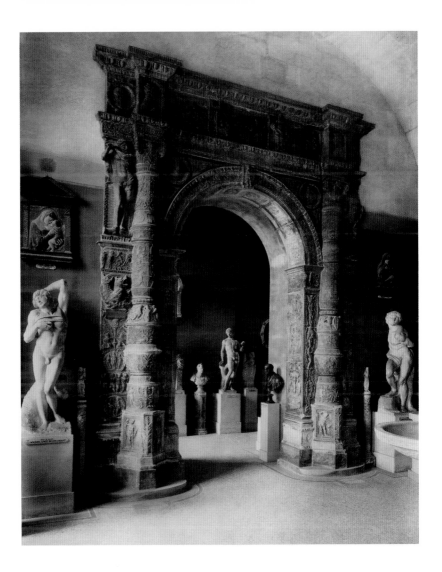

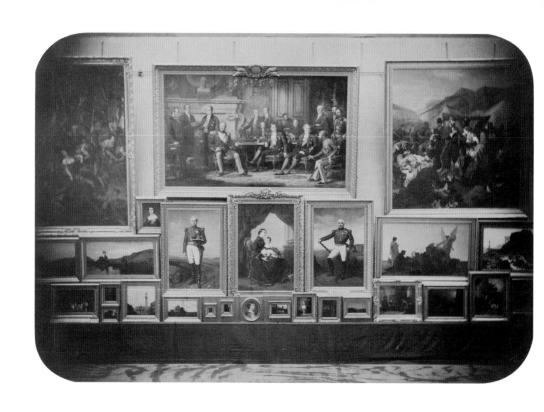

30. Pierre-Ambroise Richebourg
Vue du Salon de 1857
1857

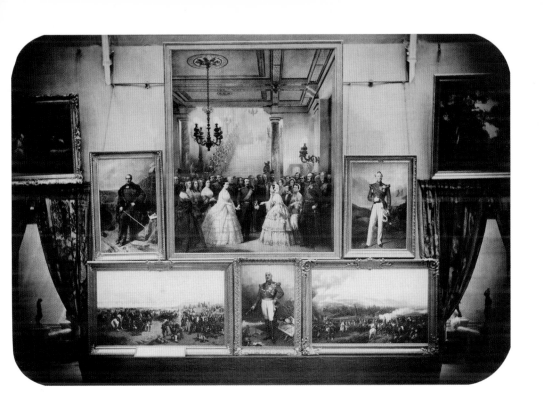

31. Pierre-Ambroise Richebourg
Vue du Salon de 1857
1857

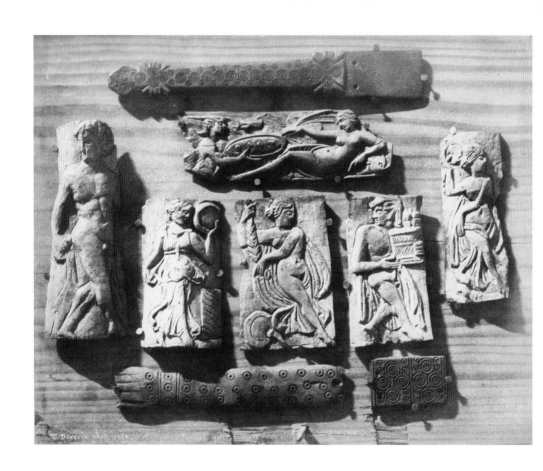

32. Théodule Devéria
Saqqarah - Neuf ivoires grecs
1859

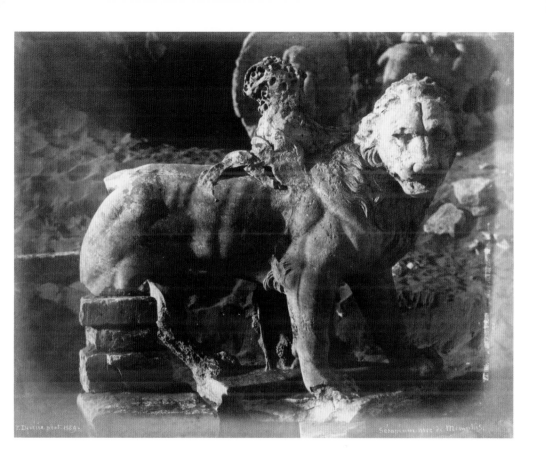

33. Théodule Devéria
Fouilles du Serapeum de
Memphis - Statue de lion
1859

34. Pierre-Ambroise Richebourg
Vue intérieure du pavillon chinois
de l'impératrice à Fontainebleau
1863-1870

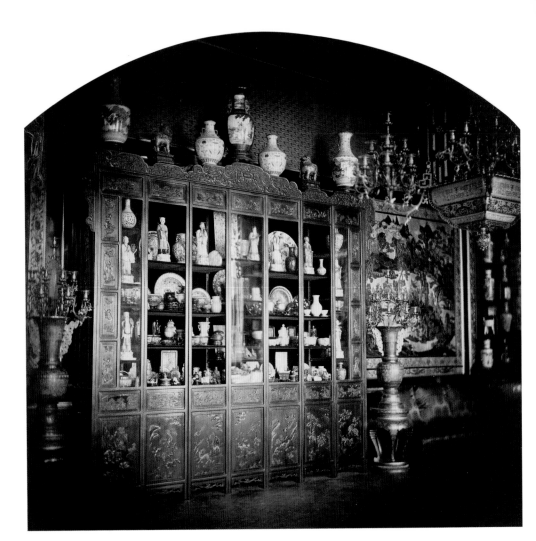

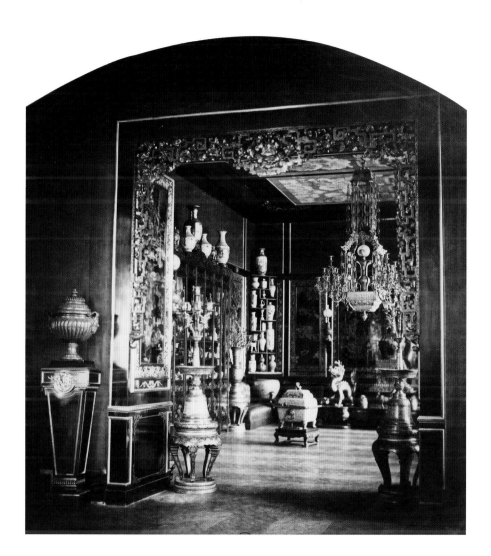

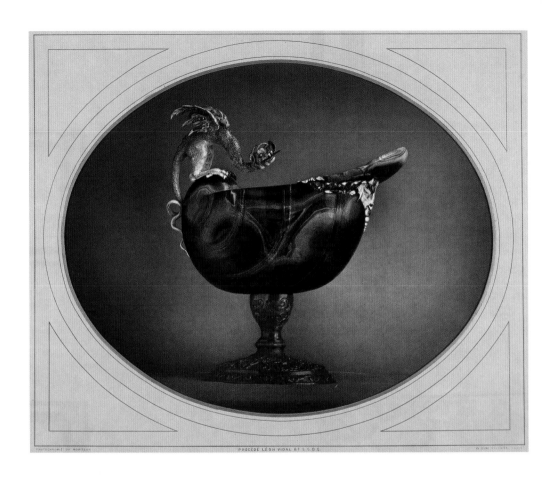

35. Pierre-Ambroise Richebourg
*Vue intérieure du pavillon chinois
de l'impératrice à Fontainebleau*
1863-1870

36. Léon Vidal et Paul Dalloz
*Coupe en sardoine onyx
orientale, XVIe siècle*
1876

**37. Léon Vidal
et Paul Dalloz**
L'Aigle de l'abbé Suger
1876

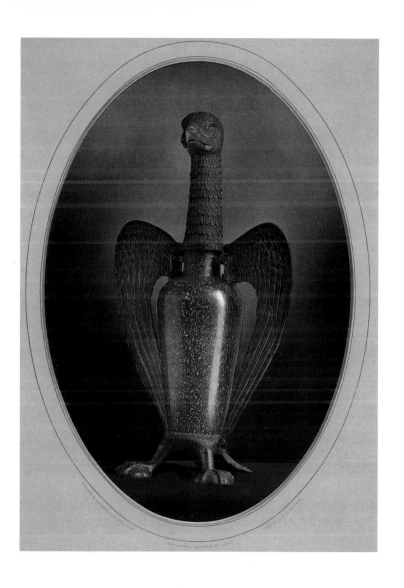

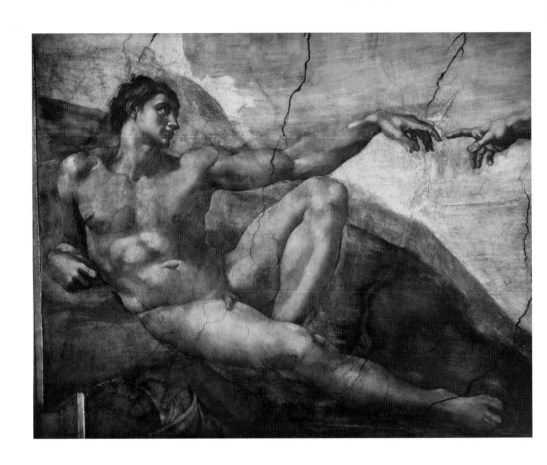

38. Adolphe Braun
*Rome, palais du Vatican, chapelle
Sixtine, fresque de Michel-Ange :
« Dieu créant l'homme » (détail)*
1869

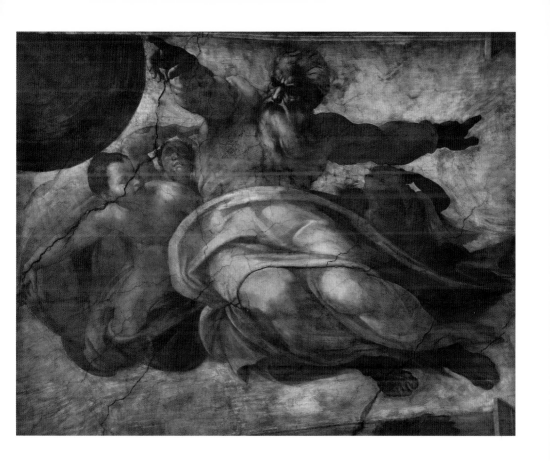

39. Adolphe Braun
*Rome, palais du Vatican, chapelle
Sixtine, fresque de Michel-Ange :
« Dieu créant le soleil et la lune »*
1869

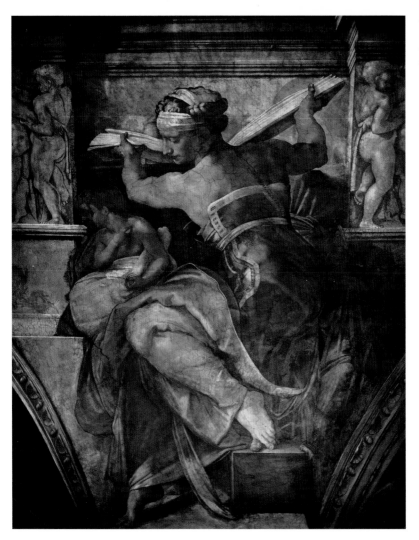

40. Adolphe Braun
Rome, palais du Vatican
chapelle Sixtine, fresque
de Michel-Ange :
« Sibylle libyenne »
1869

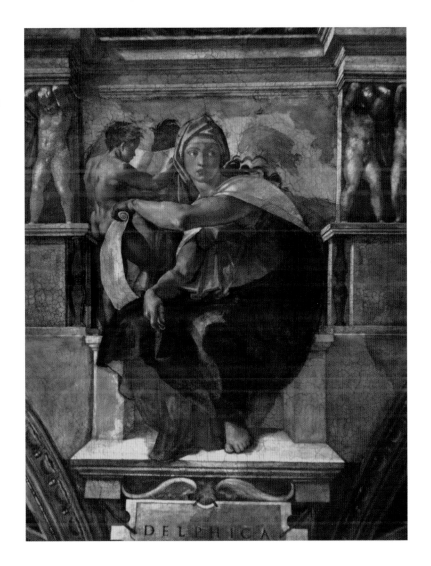

41. Adolphe Braun
Rome, palais du Vatican, chapelle Sixtine, fresque de Michel-Ange : «Sibylle de Delphes»
1869

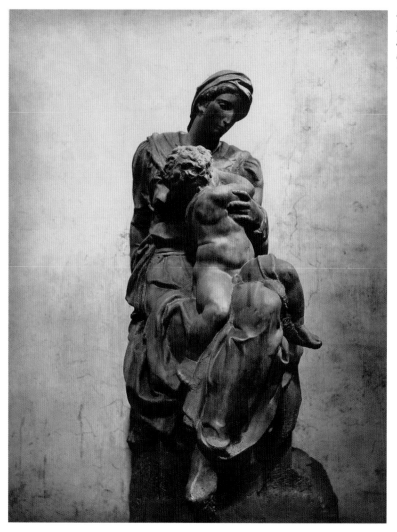

42. Adolphe Braun
Florence, « Vierge à l'Enfant », sculpture de Michel-Ange
1868

43. Charles Marville
*« Moïse » sculpture de
Michel-Ange, église
Saint-Pierre-aux-Liens
à Rome*
ca 1861

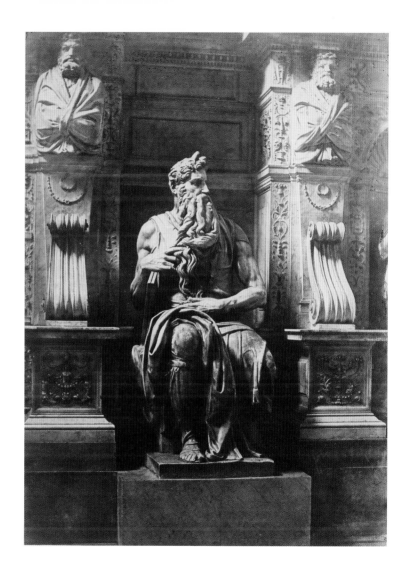

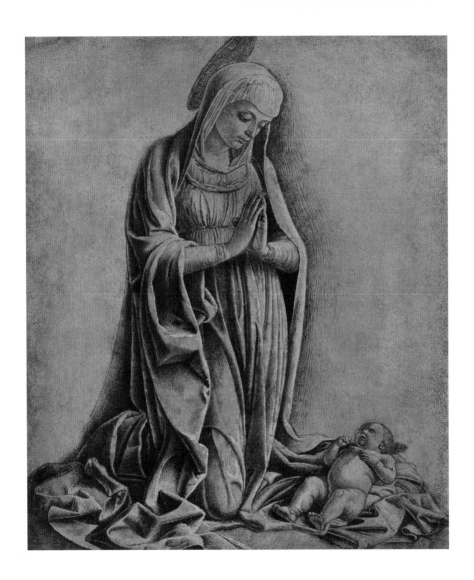

44. Adolphe Braun
Florence, «Vierge à l'Enfant», dessin d'Andrea Mantegna
1868

45. Ad. Braun & Cie
Madrid, musée du Prado, «Portrait d'un cardinal», tableau de Raffaello Sanzio
1881

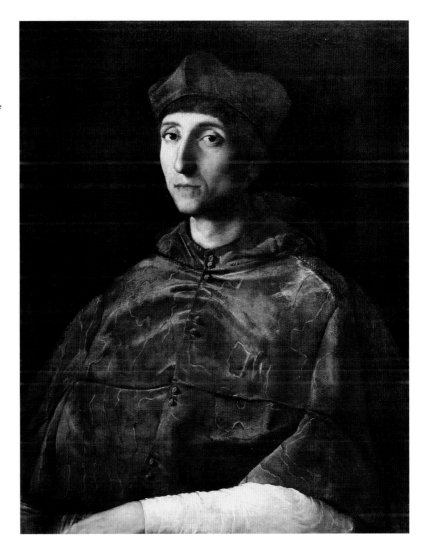

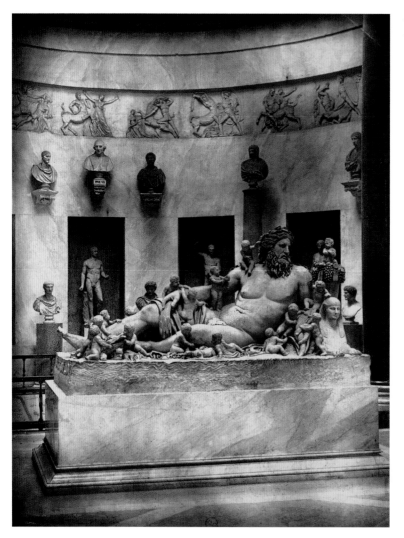

46. Stephen Thompson
Le Nil (Vatican, Rome)
1878

47. Charles Roettger
« Madona Litta »,
tableau de
Léonard de Vinci
ca 1870

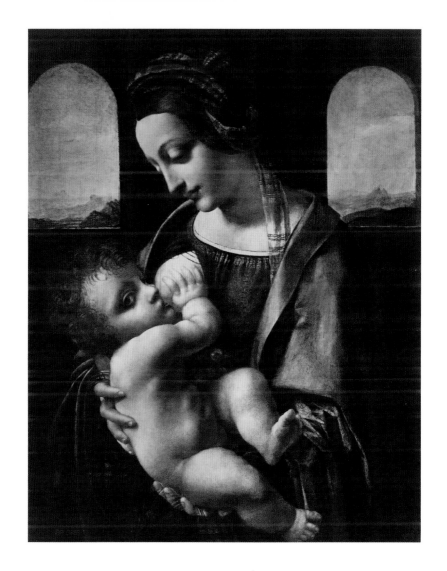

48. Anonyme
Amenamhat II en costume de prêtre (musée de Boulaq)
ca 1862

49. Anonyme
*Salle de l'ancien empire
avec une statue du prêtre
Ranefer (musée de Boulaq)*
ca 1860

50. Séraphin Médéric Mieusement
Tombeau antique au musée d'Arles
1888

51. Séraphin Médéric Mieusement
Guerrier gaulois au musée Calvet, Avignon
ca 1890

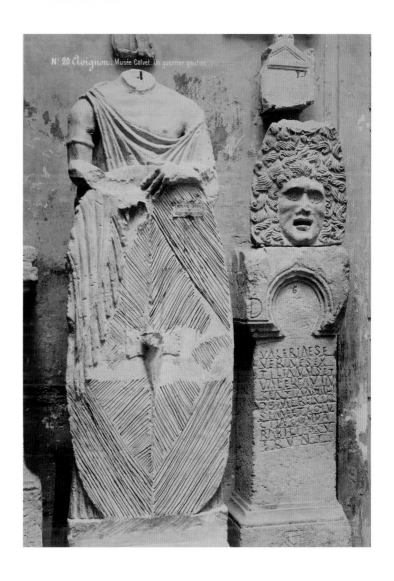

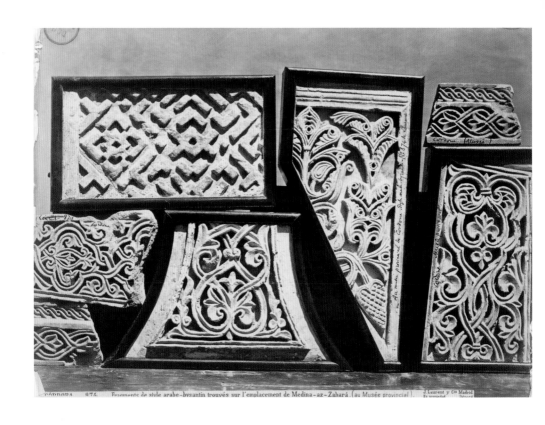

CÓRDOBA 874. Fragments de style arabe-byzantin trouvés sur l'emplacement de Medina-az-Zahará. (au Musée provincial). J. Laurent y Cⁱᵃ Madrid
Es propiedad Dépose

52. Jean (Juan) Laurent
Fragments de style arabe-byzantin
trouvés sur l'emplacement
de Medina-az-Zaharà, Cordoue,
musée provincial
ca 1870

CÓRDOBA.___ 2168.___ Salon del Museo provincial, visto desde la Seccion Árabe. J. Laurent y Cᵃ Madrid

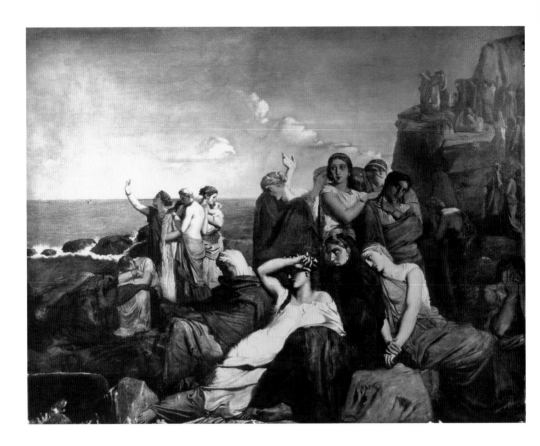

54. Clément & C^{ie} Braun
« *Sur une plage déserte, les Troyennes pleuraient la perte d'Anchise, et, pleurant, elles regardaient la mer profonde* », tableau de Théodore Chassériau (1840-1841)
1890

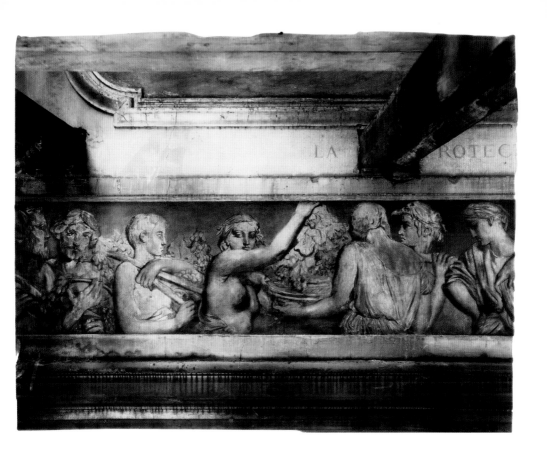

55. Clément & C^ie Braun
*« Les Vendangeurs », fragment du
décor peint par Théodore Chassériau
pour le bâtiment de la Cour des
comptes (entre 1844 et 1848)*
1890

56. Charles et/ou G. Michelez
*Salon de 1872, vue générale du jardin
et de la sculpture (côté gauche)*
1872

57. Charles et/ou G. Michelez
*Tableaux acquis par l'État
au Salon de 1879*
1879

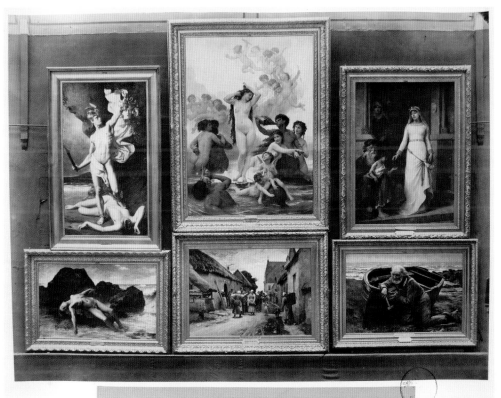

SALON DE 1879.

Bouguereau	376	NAISSANCE DE VÉNUS.
Langlois (Paul)	1759	PERSÉE ET MÉDUSE.
Moreau de Tours (Georges)	2184	BLANCHE DE CASTILLE, REINE DE FRANCE.
Renard (Émile)	2522	L'ÉPAVE.
Renouf	2530	DERNIER RADOUB; — «MON PAUVRE AMI!»
Salmson	2687	UNE ARRESTATION DANS UN VILLAGE DE PICARDIE.

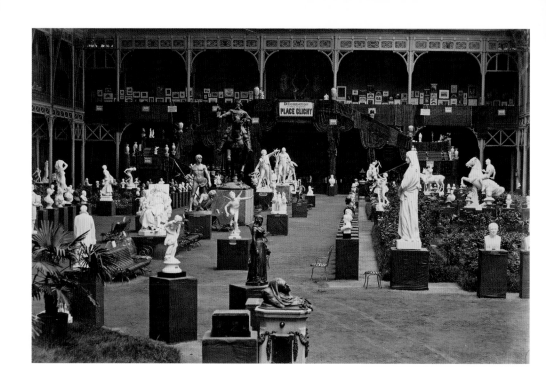

58. Charles et/ou G. Michelez
Salon de 1882. Jardin.
Sculpture. Côté droit
1882

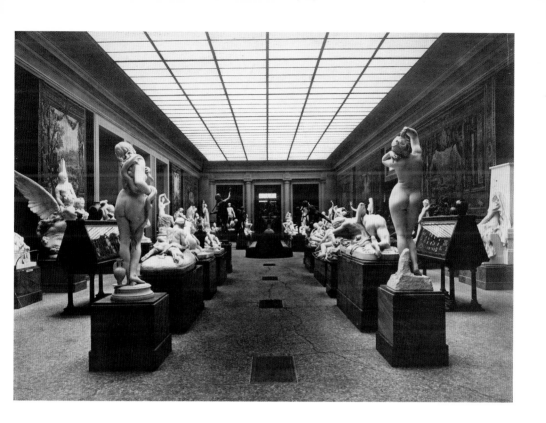

59. Anonyme
Musée du Luxembourg,
salle des sculptures
1897-1901

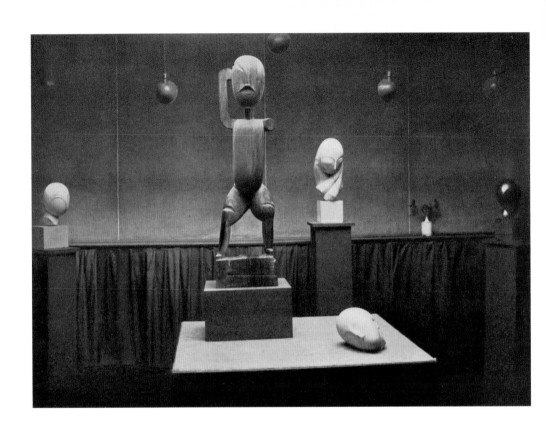

60. Alfred Stieglitz
Brancusi Sculpture,
March 1914

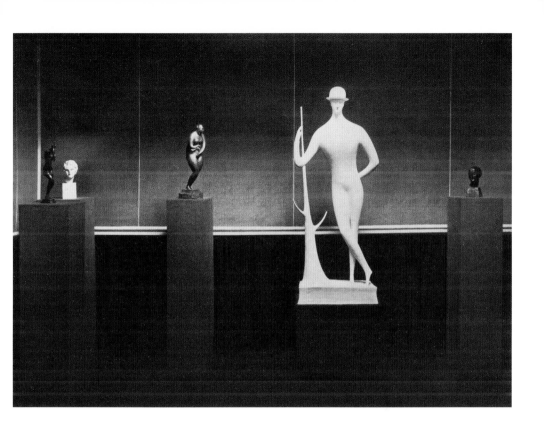

61. Alfred Stieglitz
Nadelman Exhibition - 2 Rooms,
December 1915

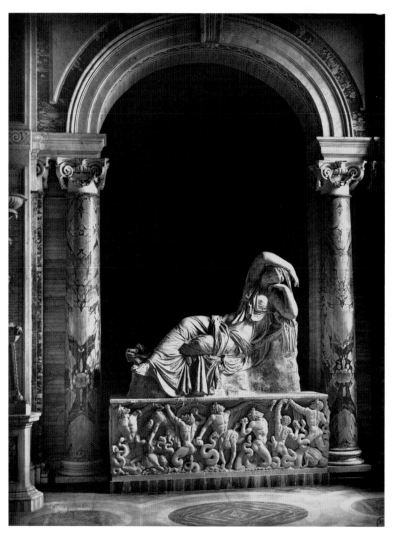

62. Stephen Thompson
Ariane endormie
(Vatican, Rome)
1878